Dragons' Domain

The Ultimate Dragon Painting Workshop

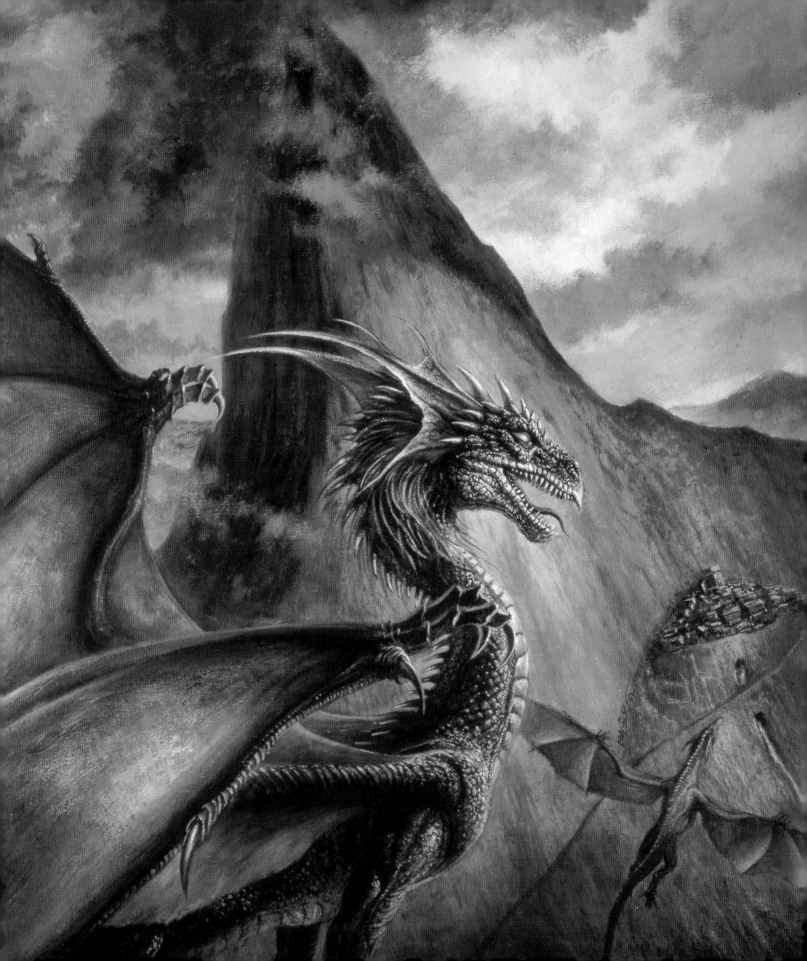

Dragons' Domain

The Ultimate Dragon Painting Workshop

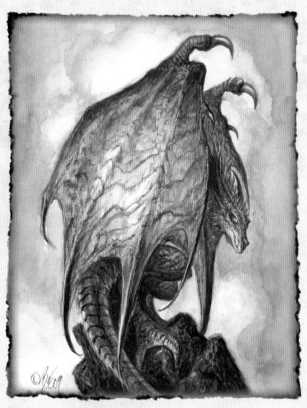

Bob Eggleton

Foreword by John A. Davis

IMPACT

This is dedicated to my Mum for all the art classes she took me to many years ago, and all the success that came later on, but she left us during the time this book was in production. She is missed and loved.

A DAVID & CHARLES BOOK
Text and images © Bob Eggleton except where indicated
Foreword © John A. Davis

David & Charles is an F+W Media Inc. company
4700 East Galbraith Road
Cincinnati, OH 45236

First published in 2010

A catalogue record for this book is available from the British Library.

ISBN-13: 978-1-60061-457-6 paperback
ISBN-10: 1-60061-457-4 paperback

Printed in China by RR Donnelley
for David & Charles
Brunel House, Newton Abbot, Devon

Senior Commissioning Editor: Freya Dangerfield
Editor: Emily Pitcher
Designer: Mia Farrant
Production Controller: Bev Richardson

David & Charles publish high quality books on a wide range of subjects.
For more great book ideas visit: www.davidandcharles.co.uk

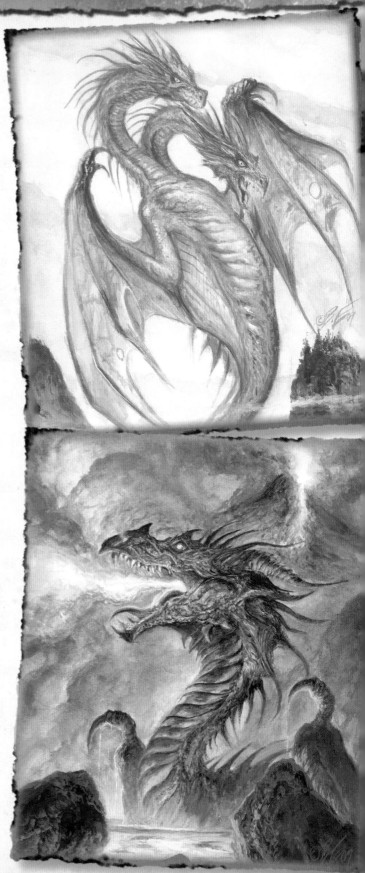

Contents

Foreword By John A. Davis

You can't think of Dragons without thinking of Bob Eggleton. It's not that Bob is green, scaly, or breathes fire (okay, maybe just a bit), but rather Bob is one of the most prolific and gifted artists to ever give life to these amazing creatures. In fact, it was one of his cold-blooded beasties that first brought us together.

I was looking through the *Spectrum 5* book for artists to do conceptual art for my *Jimmy Neutron* movie back in 2000, when I came upon a painting by Bob entitled 'Think like a Dinosaur'. The painting showed a clever dinosaur that had donned a spacesuit and was exiting one door (the prehistoric past) and about to enter another (space: the final frontier). Here was an image that not only demonstrated a wonderful talent for paint and brush, but also exhibited wit and humor – all special traits that made me pick up the phone and call Bob. After chatting it was clear that Bob and I were cut from similar cloth. We both share a love for giant monsters, science fiction, movies, and art. I had to work with this guy.

Bob created hundreds of sketches and paintings for Neutron in record time, all beautiful works in their own right. But the show stopper was his design for 'Poultra' – a gigantic alien God that is part Godzilla and part chicken! To me, Poultra epitomizes Bob. The creature is simultaneously frightening and laughable, awesome and goofy, macho and witty. And when I say 'laughable' and 'goofy', I mean that with absolute respect, for I think it is extremely important that an artist be able to laugh at himself and be childlike. Or as DEVO once said, 'Dare to be stupid'!

Since those early days of *Jimmy Neutron* we have worked together on several other projects. We have had a lot of fun and a lot of laughs. And yes, Bob always comes through with his amazing creatures! Suffice to say, several of his creations adorn the walls in my home, including that original painting of 'Think Like a Dinosaur' that first lead me to Bob several years ago. It still makes me grin.

Dragons, dinosaurs, radioactive lizards... these are Bob's passions, and that passion shows in his work. From the mischievous 'crocodile grin' of a giant perched dragon, to the interactive lighting from a blast of fire, to the beautiful translucent tones on a membranous wing – Bob doesn't miss a beat.

Wanna draw a dragon? Listen to the 'Dragon Master'.

John A. Davis

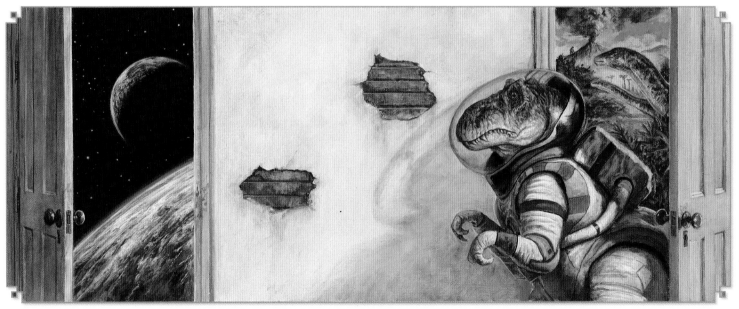

Think Like a Dinosaur

John A. Davis is the creator of Jimmy Neutron Boy Genius and director of the Academy Award Nominated film of the same name. He also directed *The Ant Bully* (2006), *Olive The Other Reindeer* (1998) and *Santa Vs The Snowman* (1996) as well as various animation shorts for his DNA Studios in Dallas Texas.

Introduction

DRAGONS HAPPEN

Now that you've opened this book… a bit of a personal introduction.

For as long as I can remember I have drawn monsters, dinosaurs and dragons. Back in the days when I was young, I can remember being asked 'So where is this going to get you?' Clearly I wasn't listening well, because years later I would make a living creating such fabulous beasts for books and films. I can't really say how I got from 'there' to 'here', only that I followed what was to me the only option and the common sense path; I had a talent and I knew it and did not wish to squander it. I didn't want to wind up years later, having followed the more pragmatic

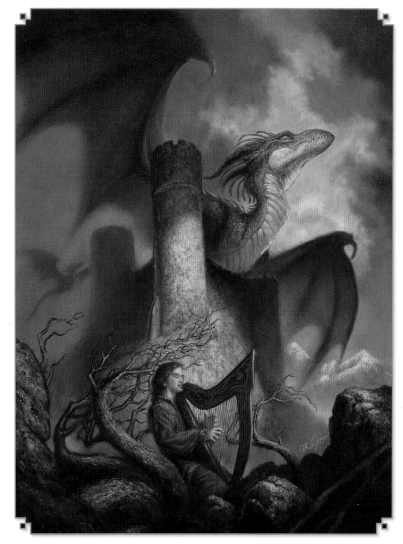

This is a book cover that I was commissioned to do. I had to show a blood red harp, and the moody feeling of a desolate landscape and castle with a sense of doom coming over it. The dragon was originally meant to be more cloud-like and suggested, but the art director suggested he be more solid.

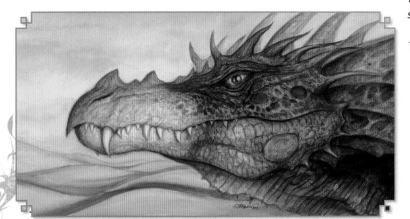

This depicts a dragon legend in the desert, and was one of the interior pages of a book. I wanted to use shadows on his head to emphasize dramatic mood.

and unromantic advice, saying 'I wish I'd done this…'. For me, it's a passion; it's connected me with some of the very best friends I have which, financial aspects not withstanding, has been the best reward of doing what I do.

What dragons do for me is not only scratch my 'creature' itch, but they also show me a sense of history. Dragons have been around in the minds of men since history was recorded. Leviathan, in The Bible, for instance, was truly a massive sea dragon, with glowing eyes, scales and flaming breath.

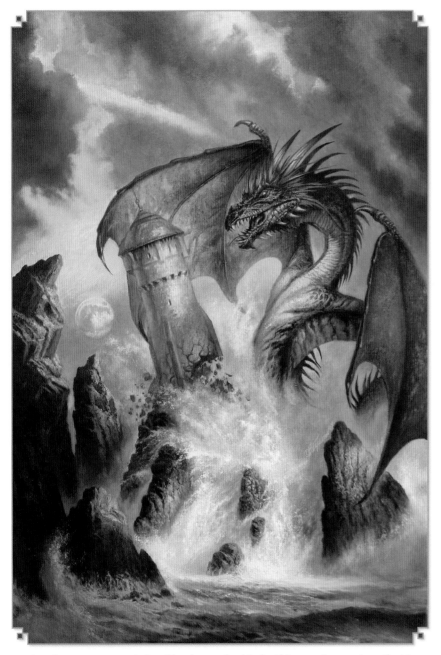

Another cover commission. The dragon had to be this massive creature that is destroying a castle with a tidal wave. Sheer joy to paint.

The real inner City of London (for which the Queen asks permission to enter, by tradition) is guarded by a horde of great dragons which stand above the daily traffic, silently looking down on the unwary hordes of workers as they go about their jobs. This is why dragons are part of our lives, whether we know it or not. They 'live' in our midst, and you'll be amazed how many you will see if you stop and take a look around you.

My hope is to show you some of my methods in creating these amazing beasts. While some may think the results of what I do are intimidating ('I can't even draw a straight line' is the normal response people give me), my goal is to break things down a bit. Some of what you will find is a bit different than my own personal methodology but I want you to see the basics, as it were, of where one might begin, given a little inspiration and some art materials. Having done art for many years it was a challenge to de-mystify my own process, put it into words and break it down. For me, art – a drawing or a painting – just kind of 'happens'. So, as such, dragons happen. Enjoy.

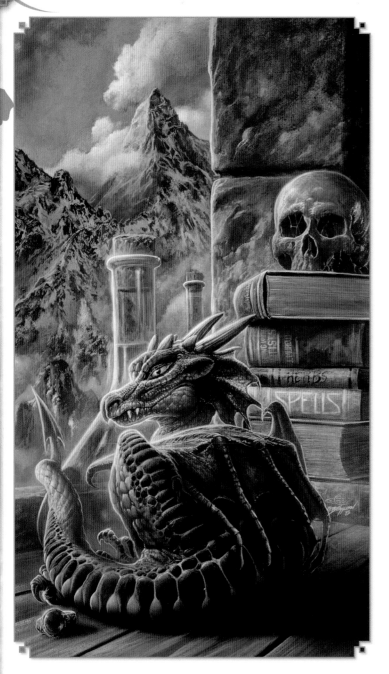

The art-direction I got was 'create a small, smart-looking dragon who happens to be a Wizard's apprentice'. They wanted emphasis on cute as well. This is typical for a design of a commercial book jacket – all the art should appear on the lower two thirds and the upper third should be kept uncluttered, for type placement.

For many years I'd been working primarily in the area of sci-fi and astronomical art – two very different genres from straight fantasy. I wanted to start making a change because my fear was that I would get known too well for one thing only and when times and fortunes changed, I'd find myself short of work. In retrospect, it was the best decision I ever made, which bolsters my theory that diversity is everything.

I was working solely in acrylics at that point. I was also learning to handle them like oils and work transparently and base this from a thin, amber under-painting.

What you will find in the rest of this book is where my work is at today. It is important to keep developing your artwork, your style and your subjects, otherwise you don't learn anything and don't stretch yourself. Most of all, however, you should enjoy your art, be inspired by it and look forward to your next piece.

This painting was done in 1993. Here we are in 2010, so it's hard to believe that 17 years have passed! But I'm doing that to demonstrate how one's style evolves. The painting was for a cover to a book called *Fanuihl* by Dan Hood.

How to use this book

This book is split into two sections – the front section where you will learn about the necessary tools, equipment and skills to create your dragon, and the second part in which you will learn how to create your very own archetypal dragons as we work progressively through the projects step-by-step.

Without living and breathing dragons surrounding us in our day-to-day lives (maybe they are – we just don't see them all of the time), it is sometimes hard to find examples to recreate, so the front half of the book also provides you with information on my inspirations and references, with advice on where to go to find pointers for your dragons. I use a combination of real-life references through lizards, crocodiles and other amphibians, as well as reading mythology to inspire me. Dragons have been alive in literature, mythology and films for longer than you and I have been on this planet, and their stories

Learn how to render the key parts of a dragon's anatomy, and the techniques you need to master.

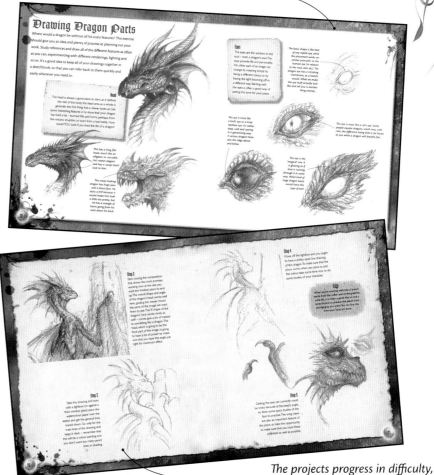

The projects progress in difficulty, but are all broken down step-by-step.

provide fascinating details and really fire your imagination. The projects section in the second half of the book is where I break down my drawing process to give you around 15 basic steps to creating your own archetypal dragons. Practise doing these often, along with your general sketching, painting and drawing, and use them to help you develop your compositional skills, as well as a launch pad for your deadliest weapon – your imagination.

Your Tool Kit

There are some basic tools that you are going to need in order to create the projects in this book, and to start creating your own dragons. Preference and taste is a very personal thing, and only you can decide which tools and materials best suit your artistic style and wallet, and there is a wide variety available. Don't always fall into the trap of thinking that the most expensive kit is the best – experiment with as many different options as possible and don't feel that you have to stick with your choice for ever more. You will find out more about how to use these tools and the effects you can create on pages 16–19 and 26–29. For now, just make sure that your arsenal is ready!

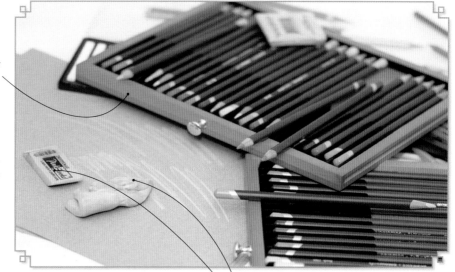

There are many brands of coloured pencils to choose from – these are Derwent Coloursoft, but there are plenty of others available. Try to get a set that's water-soluble to help with blurring and blending. Watch out for the waterproof ones!

There are two common types of eraser – putty (kneadable) and plastic. Putty erasers are best for absorbing pencil, Conté crayons and even pastel marks with little residue. They can be moulded into a fine point for precision erasing. Plastic erasers are ideal for cleaning up pencil lines on a drawing.

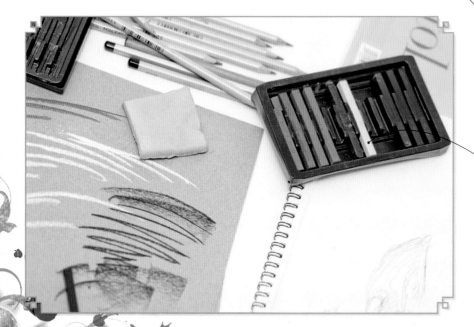

These are Conté Crayons – a very dense and hard crayon that comes in little sticks commonly in black or white, and earth colours.

You can never have too many sketchbooks. Always make sure that you have at least one with you whenever you go out, as you never know when you might see something you want to capture, or just when the urge to sketch will come over you. Sketchbooks are essential for jotting down fast ideas or even colour sketches. They come in a variety of formats, prices and bindings, so just choose one that works for you.

Make sure that your workspace is set up just as you want it, with everything within reach. You will need watercolours, pencils and coloured pencils for the projects in the book, so get those to hand.

These are dry pastels. Again, there are many brands and makes of pastels available, so just use the ones that you're happiest working with. Using pastels with watercolours is a fun way of working and provides some interesting effects.

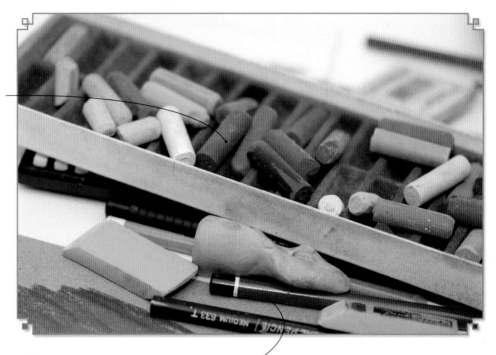

Drawing is the basis of every piece of artwork, and a skill you must perfect. Pencils range in softness (B) and hardness (H). You can use mechanical or traditional wooden pencils – mechanical pencils provide a fine, faint line, whereas traditional pencils can be used needle-sharp or slightly blunter for a softer line. Use whatever works for you, your piece and your budget.

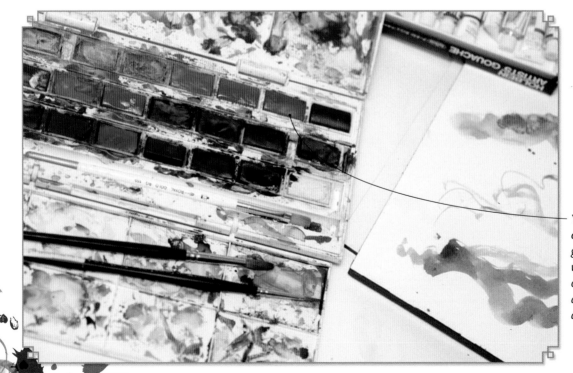

You start by buying one, but I can guarantee that you will end up with lots of watercolour trays and palettes in your arsenal.

We won't be demonstrating oils in this book, but when you've mastered water-colours that's the next level for you. This bottle contains a substance called Liquin which is a medium that speeds up the drying time of oils.

When you start using oils you'll go through brushes like nothing else. Brushes are one area where cheap isn't always best – there's nothing more annoying than having to tease out a rogue bristle.

Everyone's set up is personal, and probably won't be the same as the next person's. Using oils is no different – some people like neat palettes to hold on their thumb, while others would be just as happy messing up an old table top with the paints. Everything in art is down to personal choice and taste, and as long as you're enjoying yourself then that's all that matters!

Basic Drawing Techniques

It's not what you work with, it's how you work with it. Most people naturally have a preference for a particular medium and you must find what works best for you and what you enjoy using for the art that you create. Don't feel that you need to be tied to one particular medium or technique – the most important thing is to have fun and experiment.

Pencils

Pencils are simply graphite. You can buy them in various brands and at varying thickness, hardness or softness. Mechanical pencils are a pen casing that you can insert graphite rods into and draw with. A lot of professionals work with them because you don't have to stop and sharpen the wood casing like you do with traditional pencils. Pencil graphite can be as hard as a 9H, which makes a very fine line, down to an HB, which is the most common pencil that people are used to. The softer B range goes from a 2B to an 8B which is very dark, thick graphite. I tend to use the B pencils, because I like the textures in the pencil work, and that it shines when it's down on paper. Hold your pencil in whatever way feels comfortable, and try and use flowing arm movements, rather than working from the wrist.

Charcoals

I like working with charcoal pencils. There are lots of different varieties available, and most art stores stock them. They tend to produce a very black, solid line or can be used for excellent shading. Sharpen them with sand or glass paper.

Conté crayons

Conté crayons are a compressed pastel with a French name. They come in small sticks in varying colours (usually earth colours, and black and white). They also come with wood casings around them like a pencil. They tend to be harder than pastels, but blend easily.

Paper

I like to collect paper. You never know when a certain surface or colour of paper will strike your fancy to create something interesting. It's always intriguing to imagine what you will create on a given piece of paper, and you often find that the paper itself inspires you to create something magical.

tip
Start a collection of various kinds of papers to draw on and experiment with different shades, weights and textures.

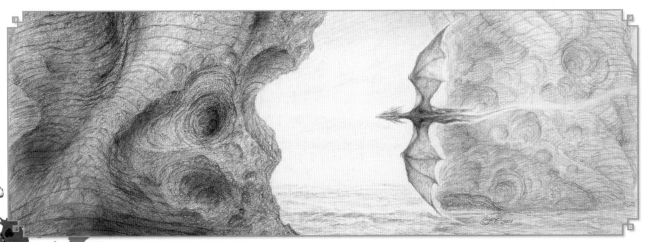

A pencil drawing for one of the interior pages of a book.

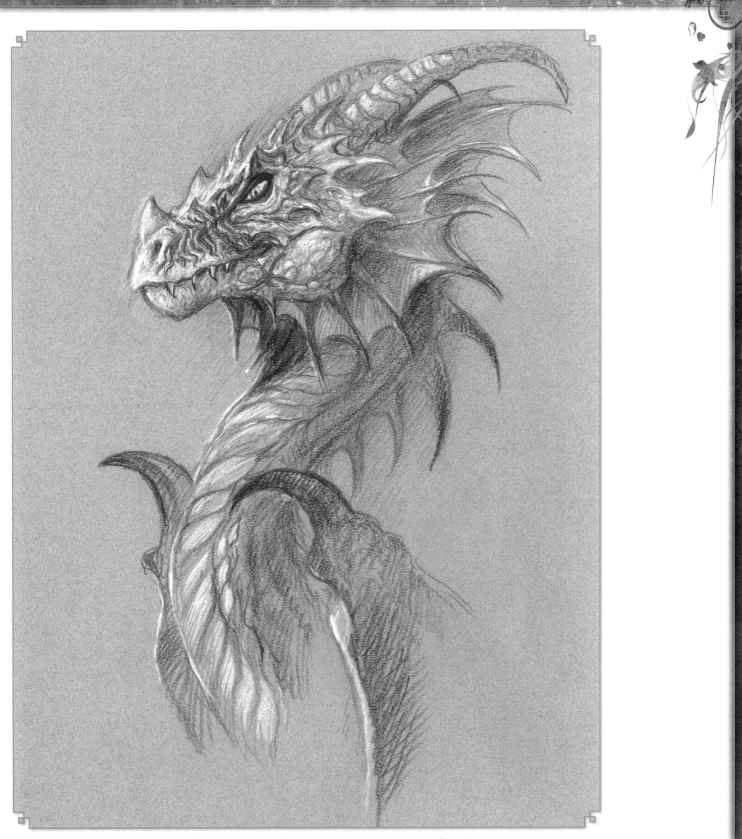

Conté and charcoal drawing, done to show use of various media in the preceding chapter of this book. This drawing took about 90 minutes to do!

1. Conté crayon.

2. 8B dark graphite pencil. This pencil is great because it makes really dark, rich drawings.

3. Soft charcoal pencil in a diagonal motion.

4. 2B pencil with cross hatching.

5. 2B pencil with diagonal motion, no hatching.

6. 6B pencil with cross hatching.

7. 2B pencil with diagonal strokes using the point. I used a putty eraser to take out some of the lines. When done randomly but carefully, it creates an interesting effect.

8. 4B pencil with cross hatching. Create the illusion of volume by hatching the pencil in opposing diagonal directions. Some areas have been erased for variety.

9. 8B pencil using the side of the pencil in dark, heavy strokes. This is terrific for creating areas of dark volume quickly. Interesting effects and textures can be created with this pencil technique, using your putty eraser.

10. Hard charcoal pencil. Great for finer marks, and can easily be erased.

11. Soft charcoal pencil. Creates a darker and more intense black.

12. Hard charcoal stick. These sticks are usually square and can be used by rubbing either the side or the top.

tip

Don't forget the best tool of all for blending — your finger!

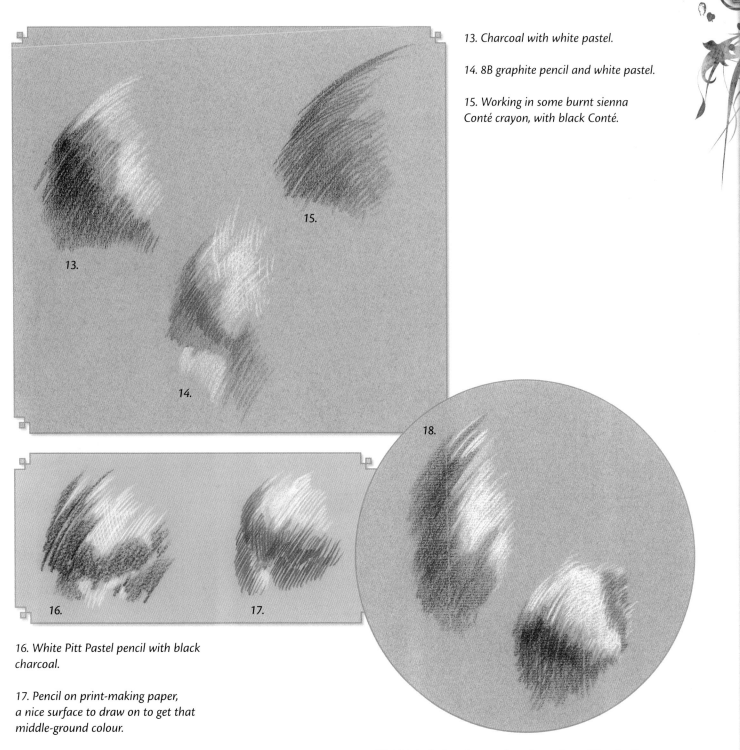

13. Charcoal with white pastel.

14. 8B graphite pencil and white pastel.

15. Working in some burnt sienna Conté crayon, with black Conté.

16. White Pitt Pastel pencil with black charcoal.

17. Pencil on print-making paper, a nice surface to draw on to get that middle-ground colour.

18. This technique is one of my favourites – it's actually more like painting! I use a toned pastel paper with charcoal and white pastel. With a toned middle ground it means that we can work darker or lighter, and also eliminates the fear of blank white paper.

Drawing Dragon Parts

Where would a dragon be without all his scary features? This exercise should give you an idea and plenty of practise at planning out your work. Study references and draw all of the different features as often as you can, experimenting with different renderings, lighting and so on. It's a good idea to keep all of your drawings together in a sketchbook, so that you can refer back to them quickly and easily whenever you need to.

Head

The head is always a good place to start, as it defines the rest of the body; the head area as a whole is generally the first thing that a viewer looks at. Get some interesting features in to show that your dragon has lived a bit – burned frills and horns, perhaps, from the volcano eruption, or scars from a lost battle. How would YOU look if you lived the life of a dragon?

This has a long, flat head, much like an alligator or crocodile. He's rather elegant and has a 'swept back' look to him.

This nasty-looking dragon has huge jaws and a blunt face. He lacks a frill because it would make him look a little too pretty, but he has a mangle of horns going from his neck down his back.

Eyes

The eyes are the window to the soul – even a dragon's soul. The eyes provide life and personality. No other part of an image can change its meaning simply by being a different colour, or by having the light bouncing off in a different way. Starting with the eyes is often a good way of setting the tone for your piece.

The basic shape is like that of any reptile eye, while the placement works on similar principles as the human eye (in relation to the nose, ears etc). The dragon eye has a nictating membrane, as a lizard's would. What we make the eye itself actually look like and tell you is another thing entirely…

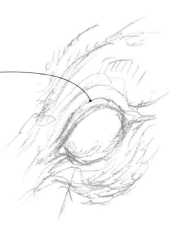

This eye is most like a cat's eye. Some people equate dragons, small ones, with cats, the difference being that a cat hisses at you while a dragon will breathe fire.

This eye is most like a bird's eye or a truly reptilian eye. It's rather deep, cold and staring in a galvanizing way. A serious dragon! Note also the ridge above and below.

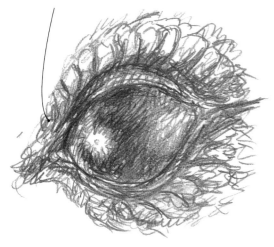

This eye is the 'magical' one. It is glowing as if lava is running through it in some way. What kind of huge dragon beast would have this type of eye?

Teeth and Mouth

Dragons are carnivorous at best – omnivorous at worse. You need to make sure that your dragon has the teeth to be able to eat anything that takes his fancy. The teeth are an important feature, so take your time thinking about them and getting them right. Make sure that they have an overbite, where the top row of teeth (maxilla) are longer than the bottom row (mandible). Dinosaurs are the best references for drawing dragons' teeth.

The upper jaw has a lip, as it were, that overlaps the teeth, whereas the bottom jaw is lipless, with teeth that seem to poke straight out from it.

Now you can really see that overbite!

Frills and Horns

These are what distinguish your dragon. Not every dragon has to have them, but they are a good story-telling feature. Some dragons may take a pride in their appearance and keep theirs looking pristine, while others may have battle scars and chunks missing. The choice is yours!

This is the neck and jaw frill that extends out. Dragons invariably have these great frills that come out of the sides of their heads, and usually connect to the bottom of the jaw someplace. Look at lots of other examples for references and ideas on how to render your dragon's horns and frills.

Wings

The dragon's wing – another likeness to the dinosaur. Bat wings are an excellent reference to use for a dragon's wing, as they have that weird, membranous stretched look that makes them look reptilian(despite the fact that bats are not reptiles!). Check out pterodactyls as well.

Here's one way of doing those bat-like wings. Remember they'll fold up like the spokes of an umbrella when the dragon's not using them.

A big mistake that a lot of would-be dragon artists make is to just stick the wings out of the back with no musculature or support. In the case of a dragon having both forearms and wings, make them this double shoulder in which the wing has its own musculature and works independently of the arm.

Remember that wings are essentially extensions of arms and that, where the wing's ribs all come together are basically fingers, and aside from the clawed 'thumb', the rest of the fingers form the ribs of the wing.

Here are some more ornate and imaginative wings. Think about the textures, as they don't all have to be the same. Are they membraneous? Or heavy and thick?

The forearm would be like any human forearm or any living animal's forearm, as form follows function in nature – be it real or supernatural. Think about the impact that having forearms will have on your dragon's wing, and try to have a clear solution in mind.

A dragon's back legs would be more or less like that of some dinosaurs. Try looking at a chicken or bird for reference, as more or less the same anatomy is at work.

Legs

How many legs does a dragon have? What about arms? Are they scaley or smooth? Check out as many legs as you can (without getting into trouble!), and especially pay close attention to where they join the body, how they bend and the response they make to bearing weight and moving.

Claws

Claws are important for making the dragon look believable, in much of a way as a person's hands are. Refer to lizard claws, and even bird and chicken feet because that's the best living analogue to use as a model. Study how they work, where the joints are, how they wrinkle and stretch and grab and grip things, as well as how they aid balance and running.

Think of them as like the dragon's hands. Include a bit of webbing between the fingers, with the nails jutting out and over the top of the finger.

Look at how a chicken leg is built and then look at this picture. You won't find a better reference point than that.

Tail

You can really go to town on the tail. It can be an anatomical feature as you would expect, but it can also be a deadly weapon. Strong, fast and accurate, it can take out an opponent with a single swipe. Putting a point on the end can also be deadly.

This tail tapers down to form that almost clichéd arrow on the end of it. It makes for a fun design element, especially if your dragon has some whimsical attributes to him.

This is a more 'hostile' dragon tail – very textured and rough. One would expect the owner of this tail to not be of a good disposition! It's amazing what you can glean from a character just by the way he looks, isn't it?

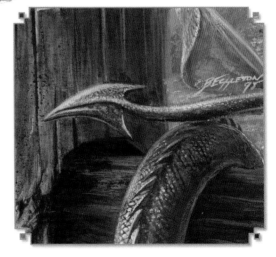

Watercolour Techniques

Watercolour paints have been used for hundreds of years. J.M.W. Turner and John Constable are two British artists who spring to mind, while in the USA Edward Hopper, Winslow Homer and Andrew Wyeth were well known for their watercolour use (as well as oil paints).

Watercolours and gouache

Watercolours are primarily the colour media used in this book.. Although we also use gouache, coloured pencils and pastels, all of the projects use watercolour as their basis. Watercolours can be used to create a variety of effects, from colour washes over an entire piece, to a variety of tonal washes in an area of detail and texture. Varying the ratio of water paint can create an amazing range of depth and tone. Gouache is also a watercolour, and is often referred to as 'designers colours' as its tends to be opaque. Once you are well practised you can create a fair amount of detail in a short time. Both are easy to clean up, and don't require the use of chemicals that oils do. Here are some tricks you can do with sponges, toothbrushes and traditional paintbrushes loaded with a varying amount of water.

Trays or tubes?

Equipment and tool preferences are a personal preference which is established over time by trying out lots of different varieties. Over time you will establish which is your preferred choice, but here is some information to help you decide initially. Tubed paints tend to be very expensive – especially if you want a broad spectrum of colours – and they often harden up, which means you have to split open the tube to use it again. They can also be quite bulky if you ever want to take them out and about with you. Tray paints store better and are easier to use. You can buy large or small trays, some so small you can carry them with you sketching. Basic colour trays can be incredibly inexpensive, whereas professional tubes and watercolour trays of many assorted colours can be cost prohibitive for some.

1. This is the stippled effect you can get when using a natural sea sponge directly with colour onto the paper. Wet the sponge first under the tap and wring out any excess water, then daub in randomly.

2. Applying light to dark warm colours using a brush, and then working an ochre or yellow over that.

3. A brush or an old toothbrush, filled with paint and spattered by tapping or flicking with the end of a finger.

4. More work with a sponge and paint, but with a bit more water in the sponge.

5. A rather dry brush full of watercolour.

6. These are some of the different effects that can be achieved by using more, or less, water in the mix with the paint.

tip

Practise these techniques before applying directly to your prized work!

6.

6.

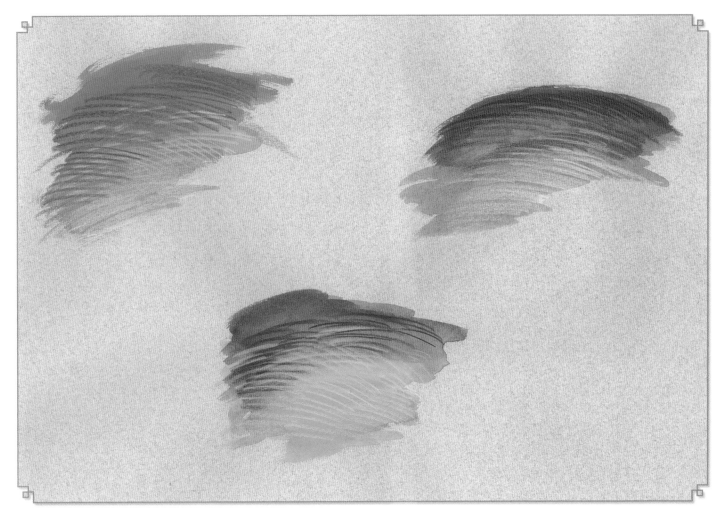

Here are some ways of working watercolours onto tinted paper, in this case, grey pastel paper. It's a trick that J.M.W. Turner used to do to great effect. Coloured pencils have been worked into the dried paint with alternative cross hatching (see page 18).

Paper

Setting foot in any art store will reveal the dizzying number of products and brands available to the artist. Don't be fooled into thinking that the most expensive item is necessarily the best, as you will quickly end up penniless and no better an artist. Paper is no exception to this rule. You will quickly learn that sketching paper doesn't have the required density or bulk to be able to take the watercolour paint without warping or tearing, so traditional watercolour paper is essential. Try out different weights and finishes, however, until you find one that you like. That really is the best way of figuring out what to spend your money on. Similarly, watercolour paper is no good for sketching or roughing out on – the paper's surface damages easily when you are using an eraser heavily. Traditional cartridge paper, either out of a pad or loose, is ideal for quick pencil work – and cheap too!

Watercolour swatches were laid down onto the tinted pastel paper, before a gouache-loaded brush was daubed over the wet paint and dried immediately with a hairdryer. This has created these great 'accidents' of layers of paint bleeding into each other.

tip
Pastel and watercolour papers need to be taped to hard board using masking tape to prevent the paper from warping.

Inspirations and References

The dragon is at the centre of most of our myths and legends, but its true origins are hard to find. However, this mythical creature inspires magic and mystery for many people.

Dragons have appeared in literature as far back as The Bible; the monster known as Leviathan in the Book of Revelations is a dragon, as is The Nun in The Koran. Recordings of dragon-like creatures go even further back to Babylonian carvings and bas-reliefs from ancient Egypt.

In more recent literature, J.R.R. Tolkien's *The Hobbit* features an iconic dragon called Smaug, while Anne McCaffery's legendary 'Dragonriders of Pern' series takes the dragon myth and turns it into science fiction. Ursula K. LeGuin's *Earthsea* books also have some incredible dragons living in their pages. There really are too many dragons in literature to list them all, so it is a good idea to do lots of research in books at the library, or online, to find the stories that really inspire you to create your own dragon art.

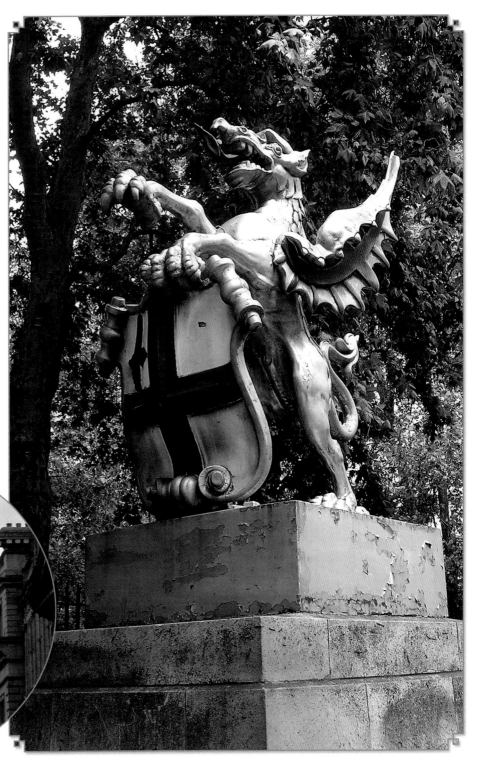

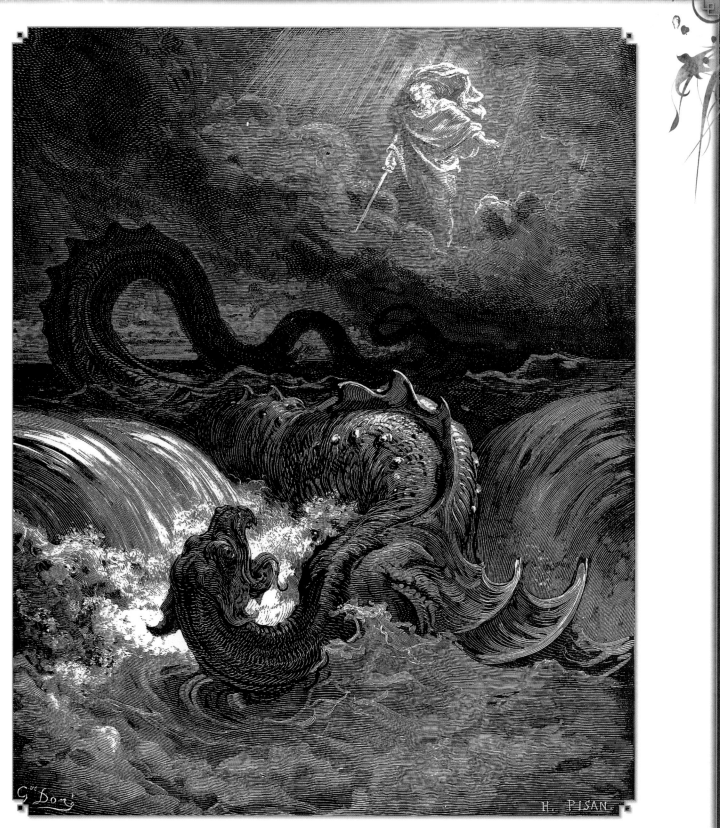

Gustave Doré – Leviathan

Dragons in art

Dragons have been with us for centuries in the work of some of the world's most renowned artists. The British painter J.M.W Turner featured dragons prominently in at least two of his works, my favourite of which is called 'Apollo and The Python', which depicts a dragon being defeated by Apollo. The 19th century Swiss symbolist, Arnold Bocklin, had dragons in some of his works, while Gustave Doré, Michaelangelo and many other classical artists portrayed dragons in some way or another in their work. One very imaginative dragon is featured in a 16th-century piece by Piero Di Cosimo, called 'Perseus Liberating Andromeda'.

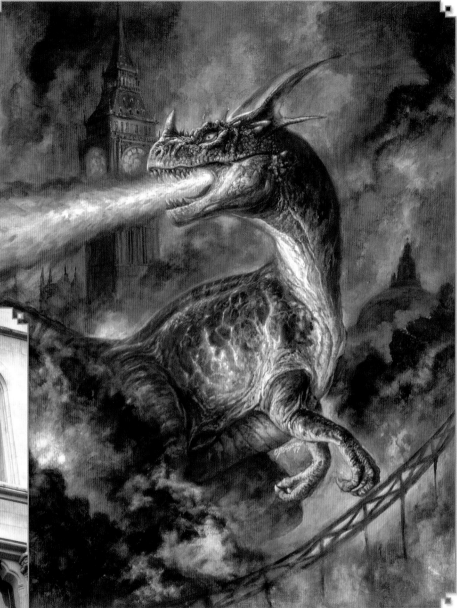

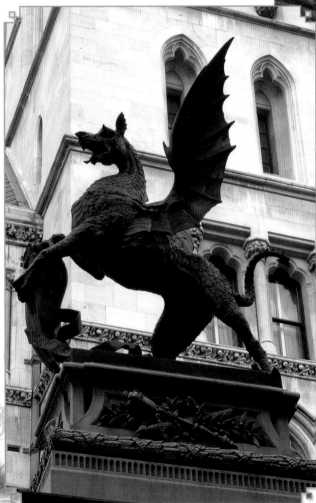

I find fuel for my imagination in all of these artists' works and more. If you are to make your own dragon and fantasy art look truly unique, it is important to take inspiration in styles from some of these great, early masters. I found that it made my work more interesting and unique than, say, taking inspiration from modern dragon artists or the various computer-generated imagery (CGI) that is around us today. That's not to say that any one artist is better than another – they all have their own voices, but classical artists, in my opinion, provide us with a more unique feeling.

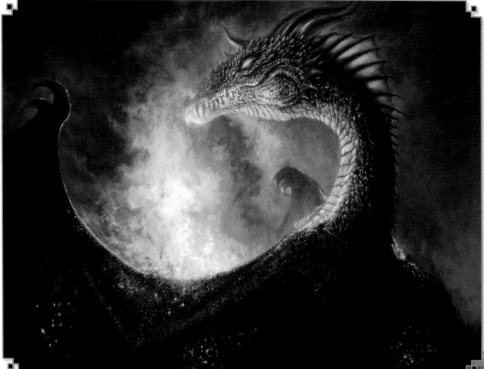

Listed below are just some of the films that feature dragons, which I use as inspiration for my art. All are available on DVD and, while some of the acting might be questionable, they're great for getting you in the dragon muse!

Dragon Slayer (1981)
7th Voyage of Sinbad (1958)
Dragonheart (1996)
Reign of Fire (2002)
Eragon (2006)
Dragon Wars (2007)

Dragons on the big screen

My attraction to dragons is for their sheer mythological origin. The Japanese call any kind of monster or beast which has a mysterious origin a 'Kaiju'. In fact, their most cinematic Kaiju is a monster that is resurrected as a result of left-over radiation from atomic bomb experiments in the 1950s. Godzilla, as the monster is most commonly known, is, in essence, a fire-breathing dragon. Later, in the 1960s, Godzilla battled a new monster from the same studio – King Ghidorah, a three-headed, winged dragon from space that breathed lightning bolts, and whose design is based, in part, on the Asian dragon.

tip

Remember not to directly copy any imagery from films, books or other art, as this would be a copyright infringement and could land you in very hot water! Use the mood of the pieces as a springboard for your own imagination.

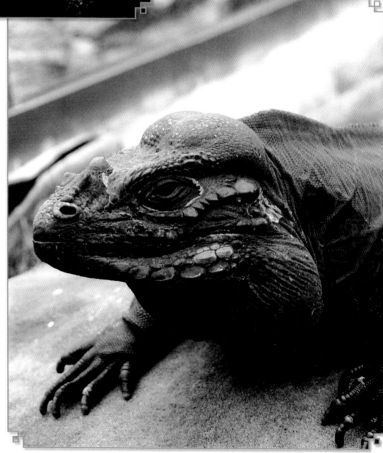

Studying your subject

So you have the inspiration, but what in our mundane world can be used to study that which is pure myth?

Collect lots of reference books and photos of lizards, birds and reptiles in general, as well as books on dinosaur skeletons and general anatomy, especially of reptiles. Make sure that you carry a sketchbook with you wherever you go, and don't be afraid to stop and sketch anything on the spot that you find, especially at zoos and museums. Some lizards are really dragon-like

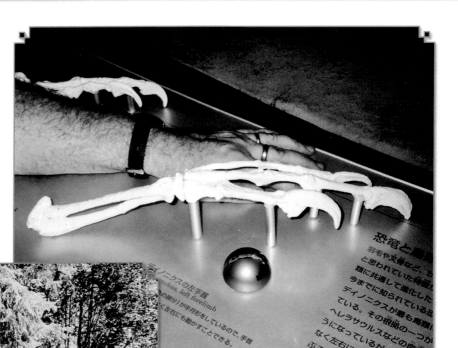

恐竜と鳥

羽毛や交叉など、か
と思われていた特徴、
類に共通して進化した
今までに知られている
ディノニクスが最も馬類
ている。 その根拠の一つか
ヘレラサウルスなどの肉食
うになっているが、ディノ
なく左右にも動くように
ぶことはできない
ていた。

ディノニクスの左手骨
...saurus, left forelimb
...の曲がり）が半月形をしているので、手首
...左右にも動かすことできる。

– in fact, the large monitor lizard, the Komodo Dragon, was so named because early sailors who happened upon the island it inhabits could think of nothing else due to its size and ferocity.

Sketch lots of dinosaur skeletons, as this will get you used to drawing the bone structure and perspective. Paying attention to these analogies will help to make the dragon seem more real, and ensuring that your work is as accurate as possible will help the fantasy element to be more plausible.

tip

Sketching in public can take a bit of practise to get used to, but the more you do it the more confident you will become, and the better your sketches will be.

Dragons come in all shapes and sizes, and their form can be defined by their function – their environment can define their attributes. For example, a 'fire' dragon would live in a hot environment among volcanoes and lava, with sparks flying through the air and flames licking anything in their path; an 'ice' dragon could exist among the ice floes and polar environments, and so forth. The dragon in the cave with treasure is overdone and clichéd… it's time to create the dragons who live in the 21st century.

THE NATURAL WORLD

In addition to photographs it is a good idea to collect things from the natural world that inspire you. Below is a list of some of the things in my collection, but the possibilities are endless – as long as you're not breaking any law, or damaging any protected habitat, take home anything and everything that catches your eye, because you never know when it might come in handy.

Animal skulls
Fossils
Leaves
Twigs
Feathers
Crystals
Rocks (of all shapes, sizes and textures)
Animal bones
Shells
Animal footprints
Bark
Conkers and pine cones

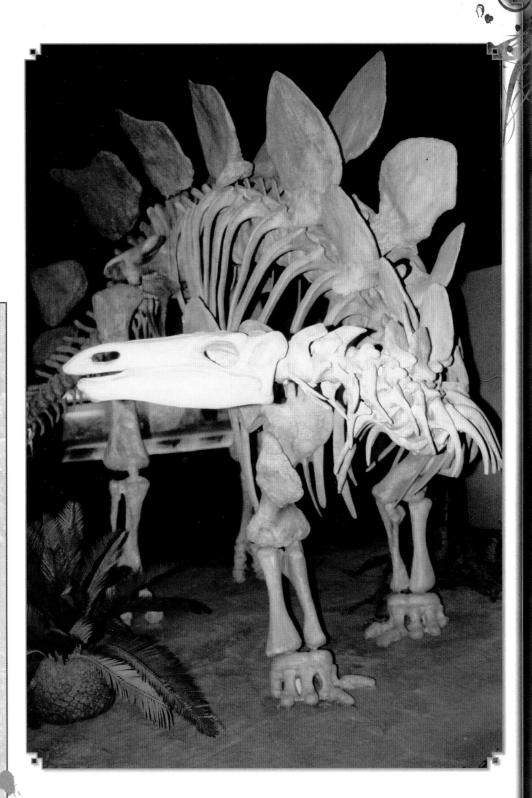

Designing & Drawing

Here's how to start and finish a 'typical' dragon, from early doodles to the finished painting, Practising is the only way to get better at your work – you need to draw as much as you can. Never go anywhere without your sketchbook and soon, over time, creating your own dragons will become intuition. We're focusing just on the dragon himself here, rather than the background or the environment he lives in. Ok, here goes!

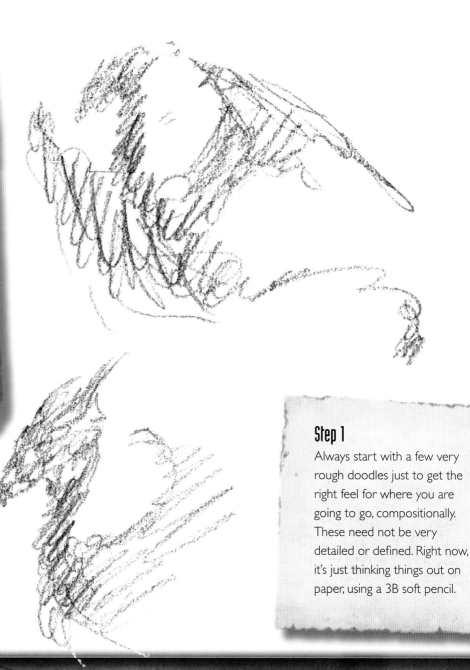

Materials

- ⸕ Pencils, 2B–5B
- ⸕ Strathmore drawing paper
- ⸕ Watercolours (your choice of colours)
- ⸕ Arches watercolour paper
- ⸕ Hard board or foamcore board & artist tape
- ⸕ Sable watercolour brushes – No. 4 is always a good choice!
- ⸕ Coloured pencils for finishing

Step 1

Always start with a few very rough doodles just to get the right feel for where you are going to go, compositionally. These need not be very detailed or defined. Right now, it's just thinking things out on paper, using a 3B soft pencil.

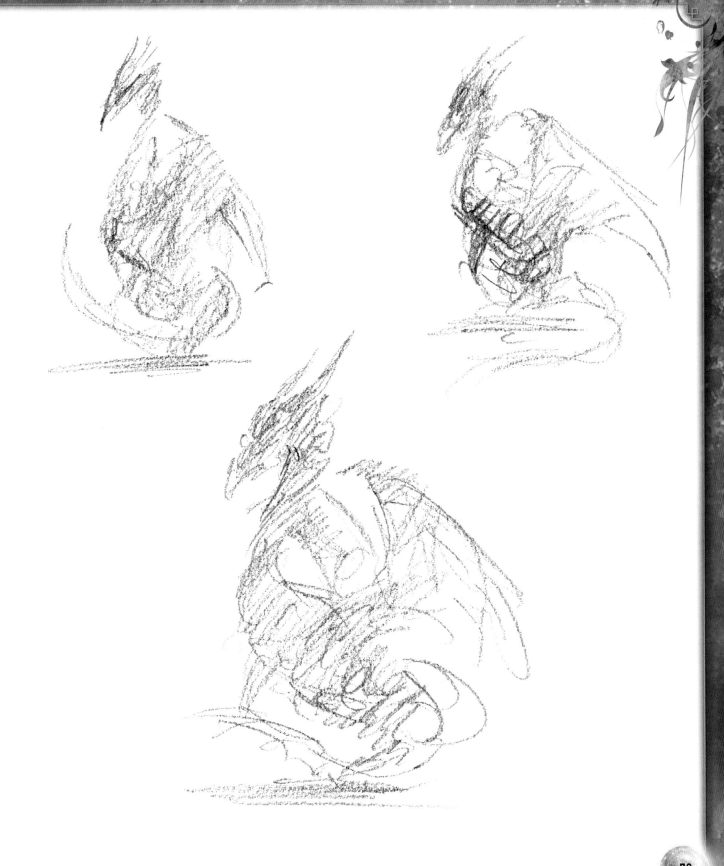

Step 2

Here is the basic reverse 'S' shape that always gives a dragon its motion. The dynamics of this shape make the dragon appear to be moving when in fact it's not. It's just gestural, and you should draw the lines quickly and with fluidity.

Step 3

Start working on the form, giving him this barrel shaped chest by drawing an egg shape. Basic cylindrical shapes, built on to the basic construction lines of Step 2, are the most simple and effective way to build up form in your characters.

Step 4

Start being more selective with your lines and begin removing any that you don't want with your kneaded eraser. It's important to keep your drawing clean so that you know which lines are the ones that are going to stay in your final image. Draw in the rough outline for his wings, and really work those shapes into the dragon's basic structure.

Step 5

Now's the time to start working in those details, using your reference images as necessary. He's looking great. Note the ribbing on the wings, making them look really three-dimensional.

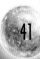

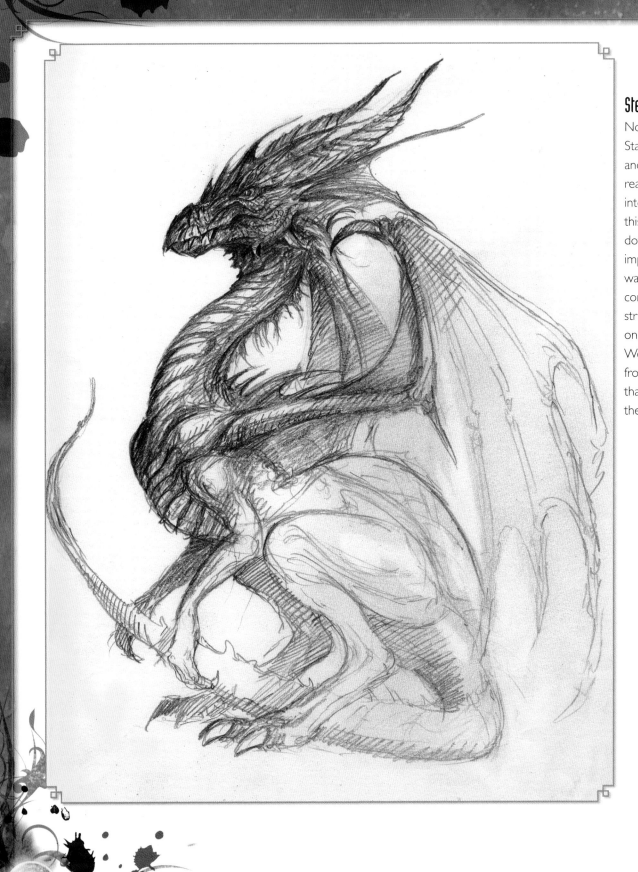

Step 6

Now the fun starts! Starting with the head and working down, really get the fine detail into the piece. Getting this detail and lines down at this stage is important, as you don't want to be making compositional and structural decisions once you're painting. Work progressively from top to bottom, so that you don't smudge the pencil.

Step 7

The drawing is coming together nicely. Time to finish his legs and complete that underwing area.

Step 8

He's really starting to look like a finished drawing, isn't he? Use your kneaded eraser to just run round the image and clean up bits here.

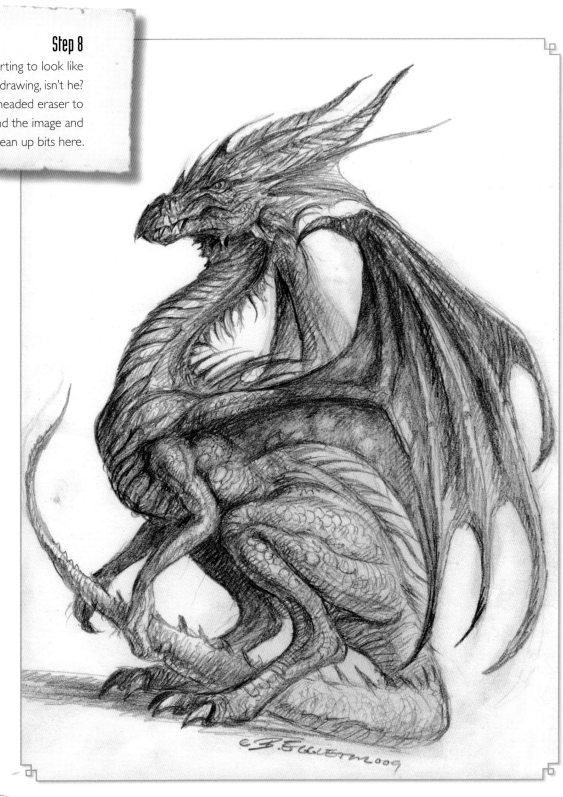

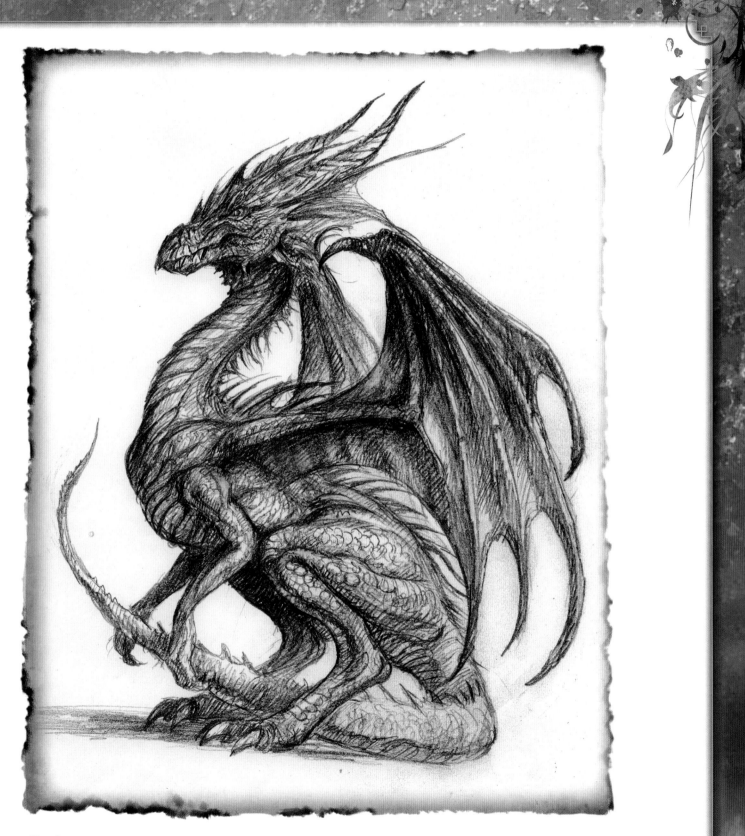

Step 9

And here's the finished drawing. Remember, this is only the first half – we now have to make a painting of him.

Painting

Step 10

Using a lightbox, or leaning on a window in daylight, transfer the drawing lines to a sheet of 2-ply watercolour paper, then tape this to a board with masking tape to prevent it warping when you get the watercolours on it. Do an initial wash to establish the areas of tone, referring back to your drawing the whole time. This is your last chance to decide on your light source – here it's coming front-on, but you can have it wherever you like. Just think carefully about what it will mean to the shading and highlights in your piece.

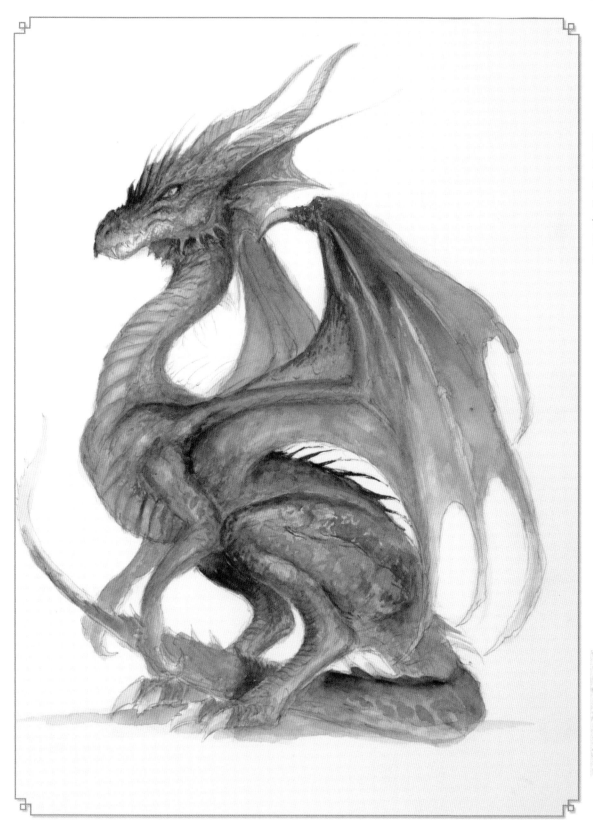

Step 11

Using some greens and browns, wash in some more detail and texture, and use a fine brush to start defining his face and wing claw.

tip

When using watercolours you should always work from light to dark, allowing the colour to build up in the darker, more shaded areas.

Step 12

Time to focus on his head. The head and eyes will define his whole attitude, so it's important that you get these as descriptive and impactful as possible, with lots of definition on the head. Use a fine paintbrush for this, and allow your tones to build up gradually. If the paper gets really wet, allow the paint to dry completely before continuing, otherwise you could end up with a muddy mess. This is by far the hardest bit of the painting, so why not tackle it first?

Step 13

You can see here how best to tape your paper to the board. Having it at this size means that you can easily turn it around and work on different areas, which is really important when you're working on the fine detail, as we are here.

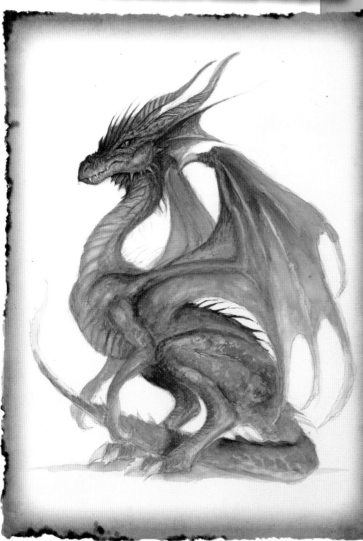

Step 14

The head and the wings are pretty much there – we will come back and pick out some last details later, but for now it's time to concentrate on the bottom half of our dragon. Continue the colours that you've established in the body, and think about the shading of the various parts as you go.

Step 15

He's really looking done isn't he? Now is the time to put your paintrbushes down and let the paper dry thoroughly. Start working in with your coloured pencils defining things more and more, and using some contrasting colours within the body. Coloured pencils will enable you to get some intricate detail and texture into the piece that watercolours just can't achieve.

Step 16

And here he is! Use some various blue and green coloured pencils to really highlight parts of him and give him a bit more 'punch', so that the whole painting doesn't fall into the browns too much. Work back into his frill and jaw a bit too, so that the overall colouring is balanced. Take the chance to work your way around the whole piece once more, but make sure that you know when to put your pencils down! It's very easy to overwork a piece, but you end up not really making any difference at all.

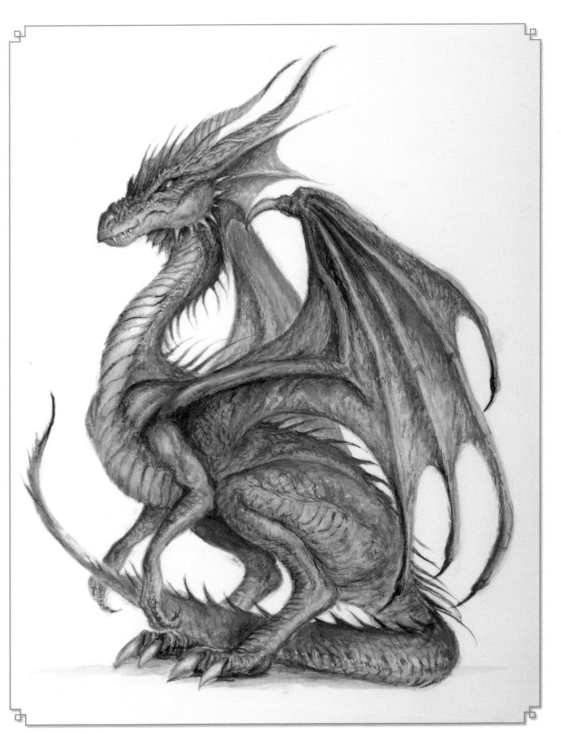

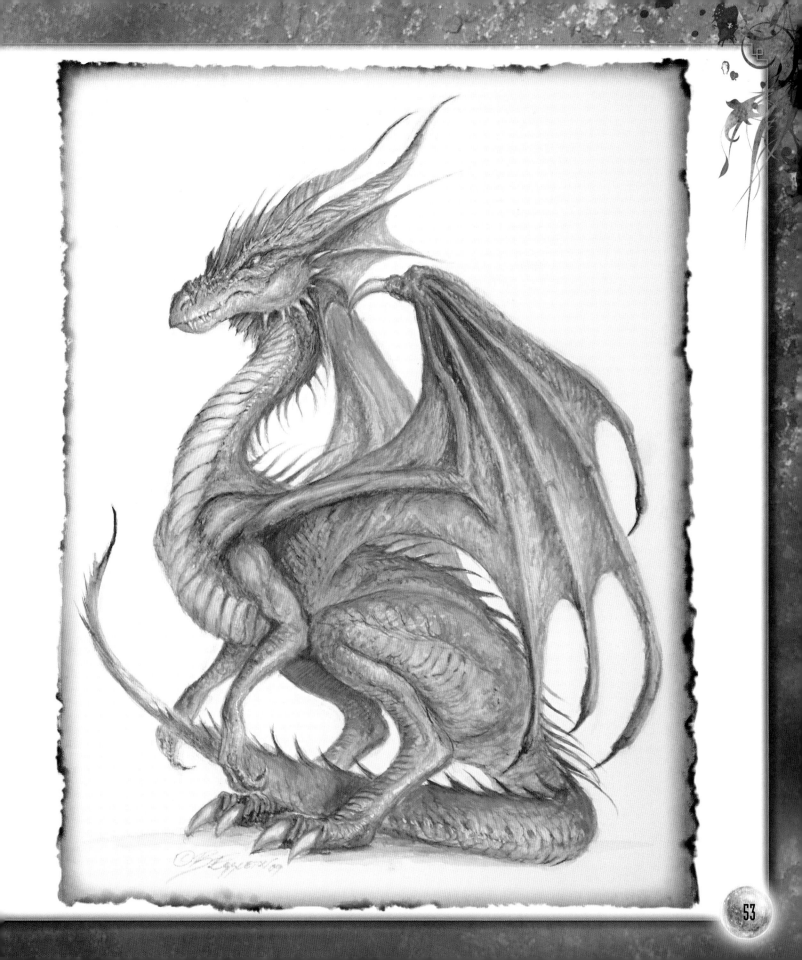

Humorous Dragon

Dragons come in all sizes, shapes and styles. Often, I get a request for a 'fun dragon' or one that looks a bit cute and stylized. The object here is to give this little fellow a dash of humanity – anthropomorphizing – as it's called.

The Back Story

The Humorous Dragon doesn't really fit in with all of the other dragons. Sure, he's scaly with sharp teeth and pointed ears, but unlike the others, he doesn't want to hurt anyone or steal their gold. He is more likely to be funny and mischievous than a fire-breathing beast to make your blood run cold – in fact, he's more likely to accidentally set fire to himself than anyone else. He likes to spend his time learning new magic tricks to play on people, rather than scaring off your worst enemy. He does a good impression of a scary dragon though, should you ever get in a tight spot and need him to help you out.

Materials
- ✝ Smooth or hot press watercolour paper
- ✝ Pencils HB–2B
- ✝ Putty eraser
- ✝ Art or masking tape
- ✝ 1 28x36cm/11x14in piece of hardboard
- ✝ Watercolours (tray or tube)
- ✝ Sable watercolour brush, No. 4 or 5
- ✝ Coloured pencils

REFERENCES
Here are some objects that will be good references for you to study:
An animal with a tail, sitting
Old books
Library
Hands holding a book/other objects
Claws and toes

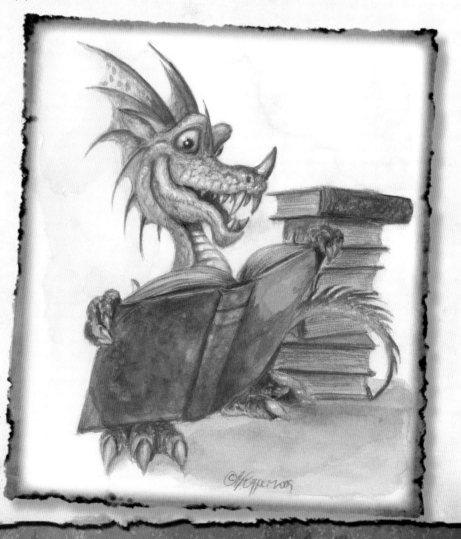

Step 1

This initial stage is all about working out your rough composition, what your character's going to be doing and what they look like. Suss out what expression this fellow will have, with three quick character studies. This should be fun to do, and you can do this in your sketchbook or on drawing paper. Because watercolour paper can be very 'fragile' in its surface, it's best not to do a lot of erasing on that. Use the cheaper drawing paper for getting the feel going.

Think about it

Work through all of the different facial expressions and poses for your character – you'd be amazed what a difference it can make to the feel of a picture. Now is your chance to really play around with the character that you've created and, most of all, have some fun with him!

Think about it

What is the focal point of your image going to be? You need to decide what part of the picture you want the viewer to see first, and which bits come afterwards. It is then a balancing act of colour and tone to make sure that it all works out as you planned.

Think about it

You'd think that the direction of the eye was such a little, unimportant thing, wouldn't you? But see how much difference having it facing a slightly different way makes.

Step 2

Get your general guidelines going. It's fun to see him reading (or trying to read) a book about magic when really we all know that he's just a dragon, and dragons can't read – can they? Keep your working loose as it will open different directions for you and keep your mind flowing with ideas.

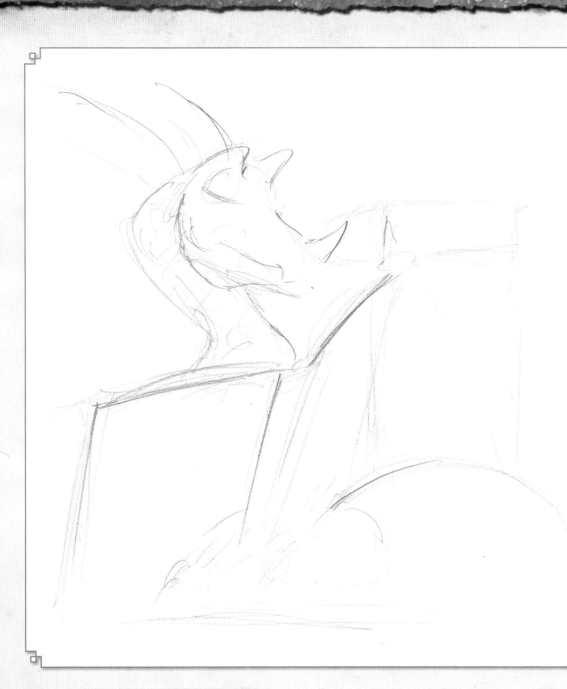

Step 3

Start placing your solid lines when you're happy with where they are, and erase your guidelines as you go. Do his head and eyes first because this is the most important and focal point of your picture, and will determine the rest of this little guy.

tip

Work roughly and loosely until you are happy with how everything's working. When you start to tighten your drawing, remember to erase the lines you don't want so that your work stays neat and clear for you to follow.

Step 4

Ok, he's looking cute now! Open his jaw a little to give him some animation, and stack some books in behind him to provide the environment. It sets off the picture nicely and creates something of interest in the artwork that supports the dragon's behaviour.

Step 5

If you're happy with your sketch it's time to take it onto the watercolour paper. Use a lightbox to pick out the final lines, or work on a window so that you can see the lines on the rough drawing underneath. Don't just let this be a tracing exercise – take the opportunity to spot and change anything that isn't working and fine tune the areas of detail around his face and claws so that they're as expressive as possible.

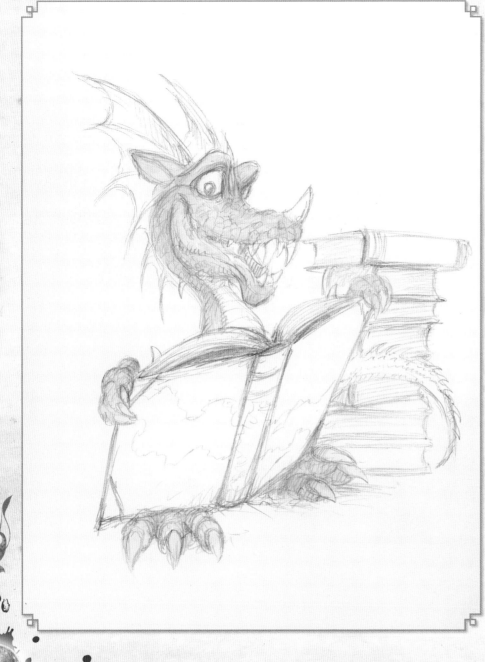

Step 6

Lay in a very light wash of some Paynes grey, mixed with a little ultramarine blue watercolour and thinned with water. Consider your lighting at this point – this fellow is lit from behind, but slightly to the left. Bear this in mind the whole time you are working on your piece, and make sure that you consistently pick out the highlights to really show this.

Step 7

I start working on his back frill and neck, which I want in a somewhat contrasting colour. In this case I use a Yellow Ochre, mixed with a bit of orange. I'm starting to 'see' him now. I also lay in a thin layer of Permanent Rose, or Alizarin Crimson-something that is not a heavy 'red' but more a nice pink. We want him friendly looking, with some respect, but not like the mouth of a shark!

tip

Always thin and test your watercolours on a separate sheet of paper until you feel good about the density. Watercolour can be tricky – it's hard to paint over or take off, so you always have to work light to dark.

Step 8

Work back into the overall colour of the face with a bit of green – Sap Green is a good choice, or Yellow-Green. It gives your dragon a bit of interest and texture which, in the end, is what makes your work your own. Do a bit of touching up to his hands and feet as well, but leave them quite unfinished for now – back to them in a minute.

Step 9

Work in some more detail and tone to his head and frill to make them look really three-dimensional and textured. Darken his eye pupils and give them a dash of Chinese White in the centre to make them look real.

Step 10

Now comes work on the book he's holding and the prop books in the background. It's important to work on the book itself first and get those textures and tones right, before you can figure how the shadows from his hands will fall on them. Go for really old-fashioned, leather-bound books – the type you might find on a dusty library shelf, with yellow pages – a real magician's tome.

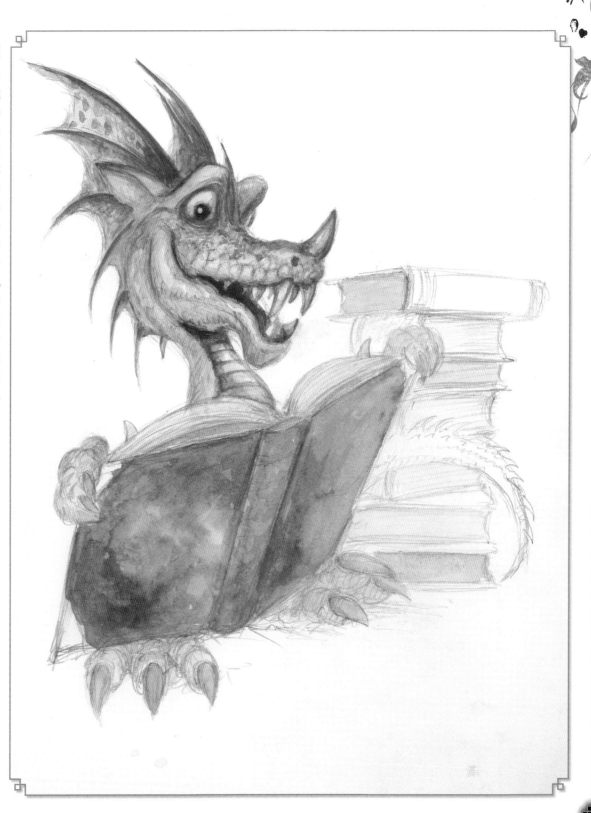

Step 11

Continue working on the book and then lay in a thin wash of blue as the 'floor'. Everything needs to be sitting so it's not all floating in the air, and we will come to the shadows next. Go over the background with a wash of thinned yellow ochre, just to give it that aged feel. Carefully work in the type of the book using a thinned black or Payne's grey.

Step 12

Run your eye around the image and check that you're happy with how it's looking – especially consider the highlights and tones, remembering where your light source is. Remember, it's all about the shadows and the placement, so check that the floor has some tone to it now. Work in some blue on his neck and tail, and finish off those books.

Step 13

Wait until the painting is dry and (mostly) flat on the board before subtly working in some coloured pencils. Use these to add detail, depth and texture, especially to the head, claws and toes areas, picking out highlights here and there. Know when to stop, and remember never to overwork a painting. And here he is!

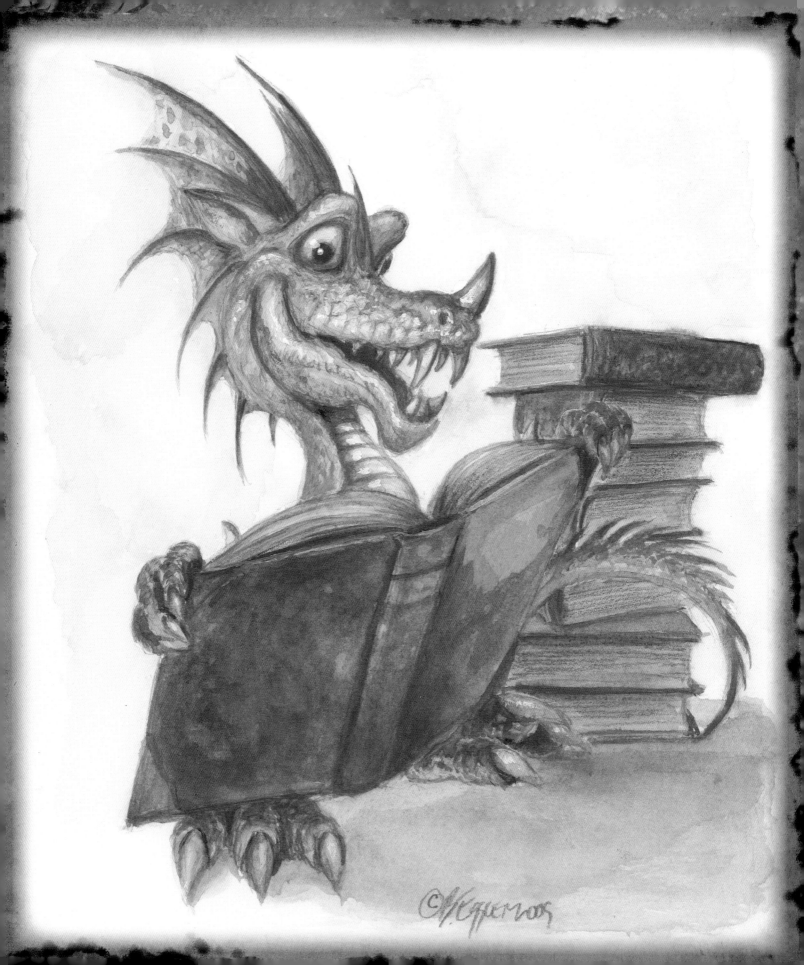

Western Dragon

The Western Dragon is a creature of legend and lore of Europe. St George was believed to have battled a fierce dragon to protect a small town, and there may even be a dash of truth to this legend – some zoologists believe that a medieval hero may have taken on a sea-going giant crocodile (which can reach up to 7.5–9m (25–30ft) in length!) which had got severely lost and wound up in an English village near the coast, driven inland in search of food, having eaten valuable local livestock. Tales abound of dragons destroying castles and this is what this most fierce creature is going to be doing in the next workshop!

The Back Story

British history is peppered with tales of dragons and fierce battles between heroes and the creatures. Western Dragons are a large, scaly, dinosaur-like creature that spark fear into the hearts of anyone who confronts them. They are generally brutal, greedy creatures who will kill and eat humans and other animals in their quest for riches. They tend to live in dark, remote mountain caves or hidden deep inside the woods. They fiercely guard their treasure – these dragons guard the City of London and the whole country of Wales. Even after death their powers have been known to continue, destroying castles and bringing bad luck to those who cross them.

Materials

- ⸼ Pencils 2B–5B
- ⸼ Drawing paper
- ⸼ Watercolour paper (hot press) and hardboard with tape
- ⸼ Watercolours (tray or tubes)
- ⸼ Sable watercolour brushes, number 2, 4, and 6
- ⸼ Coloured/water soluble pencils (your choice)

REFERENCES

Pictures of castles
Details of wings and heads
Go out with your camera and take lots of different perspective shots
Read mythology
Birds' eyes

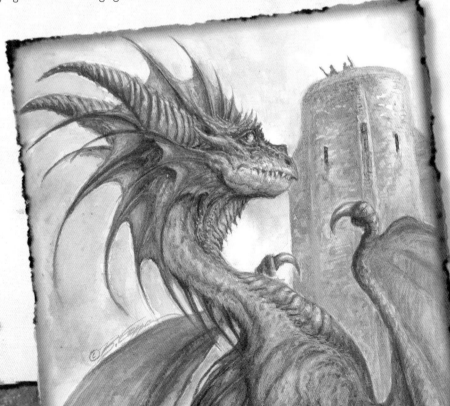

Step 1

Think about the overall composition of your piece, what elements you want to include and how you want them all to interact. Here the Western Dragon is in the foreground with a castle or fortress behind, where we suppose the gold he covets is hidden. Draw these elements out very quickly and simply as thumbnails, using pencil and sketching paper, to practise drawing the different elements.

Think about it

What parts of the image do you want the eye of your viewer to be drawn to? Decide on the focus, and make sure that you put sufficient detail and colour into that area. Overworking areas that aren't focal points will confuse the viewer.

Think about it

Scale and perspective are among the hardest things for an artist to master, but they are something that you must conquer! Only by practising, drawing roughs and thumbnails will you overcome the battle.

Think about it

It is always worth making sure that your final composition shows the facial expression that will tell so much of the story and inform what your dragon is thinking, what he's doing and most of all, whether he's good or bad.

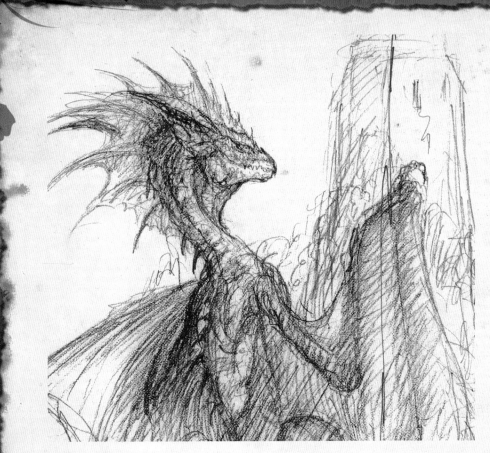

Step 2

Start honing the composition that shows the most promise, working now at the size you want the finished piece to end up. The overall shape and angle of the dragon's head works well here, guiding the viewer round the parts of the image we want them to see. The 'S' shape of the dragon's neck works nicely as well – curves give a lot of motion to something like a dragon. The head, which is going to be the focal part of the image, is going to have a lot of power so make sure that you have the angle just right for maximum effect.

Step 3

Take this drawing and now, with a lightbox (or against a thick window glass) place the watercolour paper over the sketch and get the general lines traced down. Go only for the main lines of the drawing and keep it clean – remember that this will be a colour painting and you don't want too many pencil lines or shading.

Step 4

Move off the lightbox and you ought to have a pretty open line drawing of this dragon. To make sure that the piece works when we come to add the colour, take some time now to do some studies of your character.

tip

When you're working with lots of pencil marks from the softer end of the graphite scale (B), it is often a good idea to use a spray fixative to prevent the pencil from smudging as you work. You can buy this from your local art store.

Step 5

Getting the eyes set correctly could be tricky because of the head's angle, so draw some quick studies of the face to practise. The wing claws are also an important feature of the piece, so take this opportunity to make sure that you have these practised as well as possible.

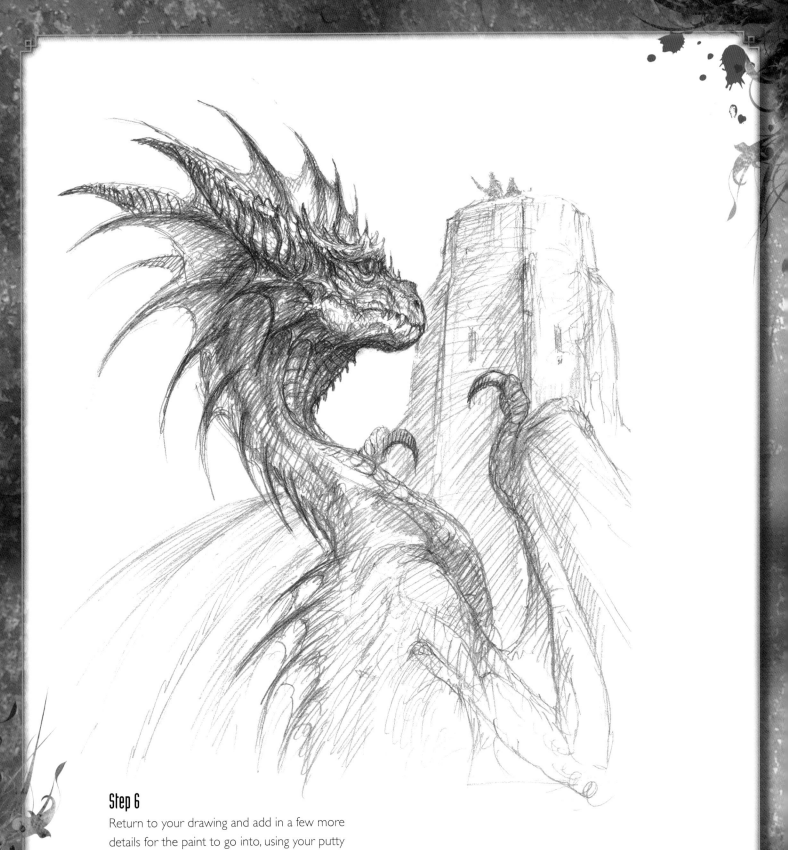

Step 6

Return to your drawing and add in a few more details for the paint to go into, using your putty eraser to remove any lines if it becomes too pencil-heavy.

Step 7

Start applying your initial washes, remembering to work from light to dark. Start the dragon with the eye (the most important part!) and work down the body adding colour and tone. He's coming to life now!

Step 8

Work on finishing the face first, because that's what will define what he is – his intent and meaning. Use mostly greens, yellows, ochres, some sepia and some Paynes Grey to give the shadow areas a lot of depth. Keep the eye looking bird-like, and don't forget your light source!

Step 9

Now it's the turn of the horns and frills. Use lots of browns, oranges and yellows, along with darker complementary tones to really pick out texture and add depth.

Step 10

Wash in some more blue sky and start working down his back with thin washes of various greens and yellows. Start adding in the scales on your dragon, but don't get too bogged down with it – there is little purpose in painting each and every scale on a dragon. The idea is to create the illusion of his scaley body by doing some areas of detail (such as under the neck) and some areas very loose to suggest movement.

Step 11

Now it's time to think about that castle he's headed for. Add in a basic wash, and then spend some time tightening up the shadows and highlights on the dragon – he's looking so good now we should finish him before moving on. Remember with watercolours that you can always add tone and shadow to a piece, but it's hard to take it away so always work lightly initially and build up your colour.

Step 12

Add another wash to the castle to build up the tone. Take this opportunity to step back and run your eye over the dragon to check you're happy with how he's looking – holding your picture up to a mirror is often a good way of finding any areas that aren't quite working.

Step 13

The trick to doing a castle and making it look like it's made of a huge amount of stones is to create the illusion of that. It would drive you crazy to sit and paint each stone, so work quickly with the paint and use various shades of grey with a touch of brown, leaving some of the white from the paper showing through to add definition. Practise on a blank piece of paper first if you're worried about working straight onto your piece.

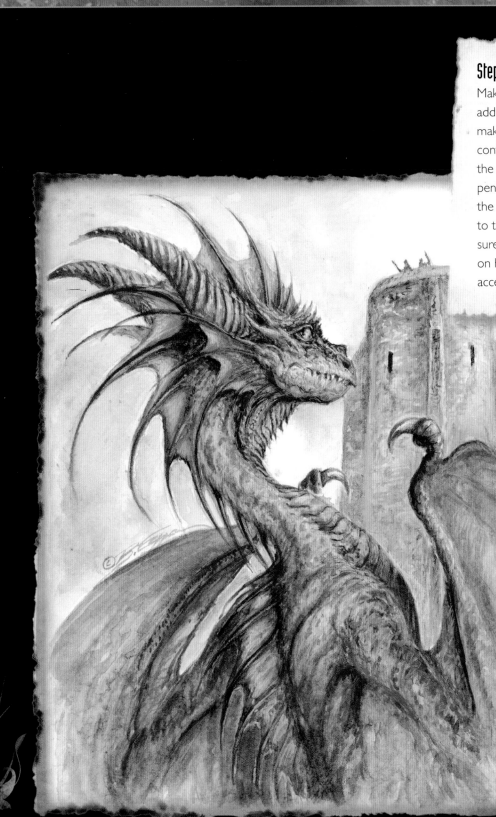

Step 14

Making sure your paint has dried, add a pale blue wash to the castle to make it sit better in the distance, and continue blending in the colours on the dragon himself. Using your colour pencils pick out some highlights using the brighter, complementary colours to the tones on his body, and make sure that the tones and highlights on his neck and chest define and accentuate the arching shape.

Step 15

Make sure that all of the pencil lines are now blended out. Use your colour pencils to lighten up the shaded areas on his back, head and face – having them too dark will draw the viewer's attention to the wrong parts of the image. Finally, do the same for the castle in the background and there you have him – your very own Western Dragon.

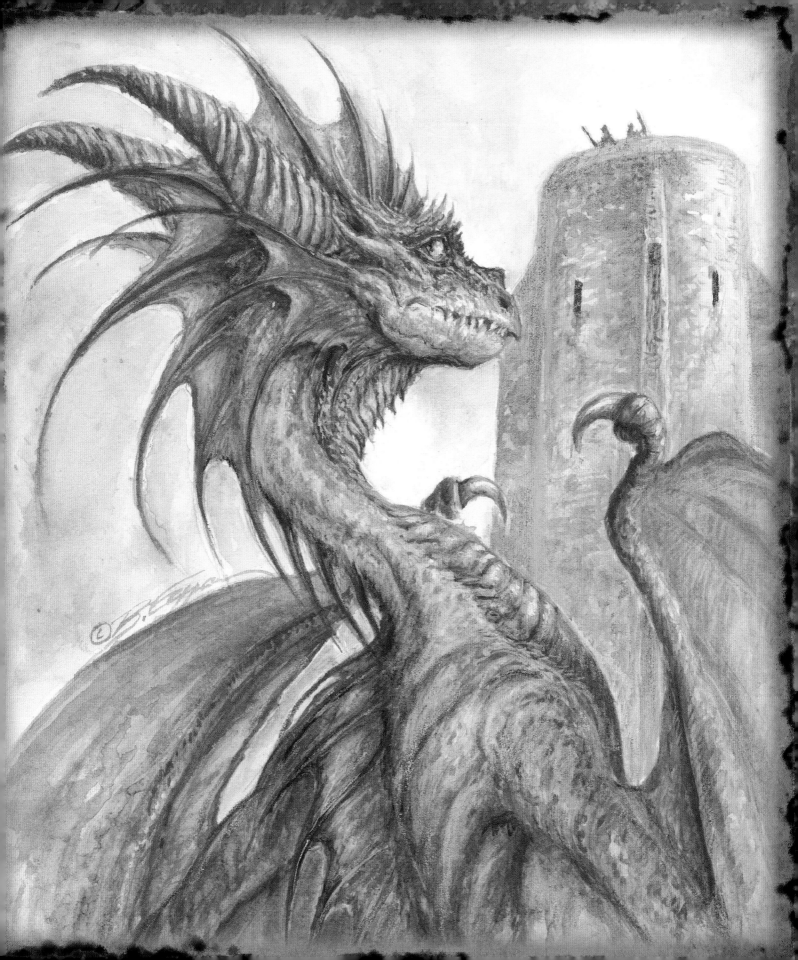

Eastern Dragon

When one thinks of an 'Eastern' Dragon one thinks typically of a Chinese Dragon – a very ornate and frill-adorned beast, that was a symbol of wisdom. There is also the Japanese Orochi Dragon, a great beast that had between two and seven heads, depending on the level it was maturing at. The Orochi was probably the inspiration for many of the monsters seen in Japanese Kaiju films, such as *Godzilla, King Ghidorah* and *Rodan*. Here is your own Orochi.

The Back Story

Unlike its Western counterpart, Eastern Dragons are revered and celebrated in Chinese culture, enjoying a god-like status. They are prominent zodiacal figures and having your child in the year of the dragon is seen as a great thing. They were said to bring rain, and people often prayed to them during times of drought. If they were unhappy, however, they could also bring devastating floods, and so commanded the upmost respect. Its only enemy was the tiger, its zodiacal opposite. Eastern Dragons were capable of shape shifting to adopt the form of other creatures, and even man. Whatever they became, they were always the most beautiful example of that creature.

Materials

⸰ 2B–5B pencils
⸰ Cold press watercolour paper
⸰ Hardboard and tape (for mounting paper)
⸰ Drawing/sketching paper
⸰ Watercolours(tubes or tray)
⸰ Watercolour sable brushes
⸰ Gouache

REFERENCES

Environments
Read mythology
Chinese dragon art
Lizards and reptiles

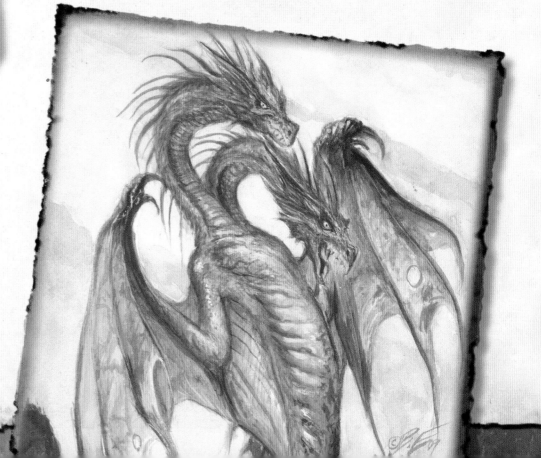

Step 1

As ever, begin by working on your thumbnail compositions. Do as many sketches as you need to be happy with the piece – sometimes that may mean five or more, but occasionally just one will do. However many you do, just make sure that you're happy with the way everything's working and that you can clearly see the end piece before you move onto your final paper. Your polished project isn't the place to work out compositional problems.

Think about it

The background environment of your picture needs to complement your dragon, rather than distract the viewer. Research your references and your dragon's back story to come up with some elements that work well in the composition.

Step 2

Time to move from the thumbnails to your full size piece. Draw a gesture line to capture the essential shape of your dragon – as with the Western Dragon the curves of the dragon's lines are fundamental to the piece. Draw a line through the upper part of the body line to help you to get an idea where his wings would branch off.

Step 3

Work on the placement and orientation of the wings, and add form to the head using simple shapes. Keep your work clean and erase any lines that you don't want to use as you go. This development work will give you confidence as you develop the sketch, and help enormously when you come to the colour as all of the detailing can simply go on the top of your construction lines.

tip

Drawing is the basis for any good painting. It doesn't matter whether you are doing a traditional painting such as this, or working in digital media. The masters knew this, and it's the first rule of any worthwhile art.

Step 4

Draw in another head for our Orochi – this is an immature version, so two heads are ideal. Don't worry, he lives 1,000 years, and has enough time to grow five more heads! When you're ready for a challenge, you can create your own mature Orochi with seven heads.

Step 5

Using one of your softer 'B' range pencils, flesh out your drawing and start working in the detail, using your references the whole time to help. The next step is to take him onto the colour paper, so don't worry about the denseness of the pencil lines at the moment.

Step 6

Put your pencil drawing onto your lightbox or window, with your watercolour paper on top, and pick out the most important structural lines. Take this opportunity to edit anything that needs working on, or to clean up areas that were previously a bit muddled. Your finished pencil piece, ready for colouring, should be clean and with faint lines that can be worked over.

Step 7

Use some Pthalo Blue and Yellow Ochre to start putting in some washes on the dragon's general body colour. As ever, work from light to dark and build the colours up in layers, rather than laying down dark and heavy tones straight off.

Step 8

Time to focus on the head. Start with the eye as usual, and work your way out to the rest of his face and head. Roughly wash in his frills for now – we'll come back and tidy them up and further refine them later on.

Step 9

Work in some more colour and start some detail on the wings. It's good to think of the wings as being a bit membranous and translucent, so try to keep the feeling of light coming through them in some way.

Step 10

Remember you're doing two heads! Wash in some colours identical to the first head. Step back and check you're happy with how the image is progressing, and tidy up any areas you're concerned about. Don't forget the mirror trick!

tip

When your paint is wet you can use tissue paper to gently blot up watercolour, and thus control how thin or thick you make it.

Step 11

Time to start working in some tones and textures to those heads. Build up the colours gradually, and remember to let the paint dry inbetween each wash, otherwise you'll end up with a muddy mess. Really focus on the eyes and tongue, using a fine brush to add detail.

Step 12

Using your references start to add in more shade and colour to the body and wings. Overlapping underbelly scales are ideal for providing a sense of motion, so add these in quickly and fluidly – remember that they don't have to be perfect, and neither do you need to paint in every single scale.

Step 13

Work your way around the whole dragon one last time, checking all of the highlights, shading and textures. Make sure that there are no pencil lines still remaing, and pick out some final details, such as in the faces and frills, with coloured pencils if you wish. Check that the key parts of the image (the heads and claws) are as strong as you can get them, but be careful not to overwork them.

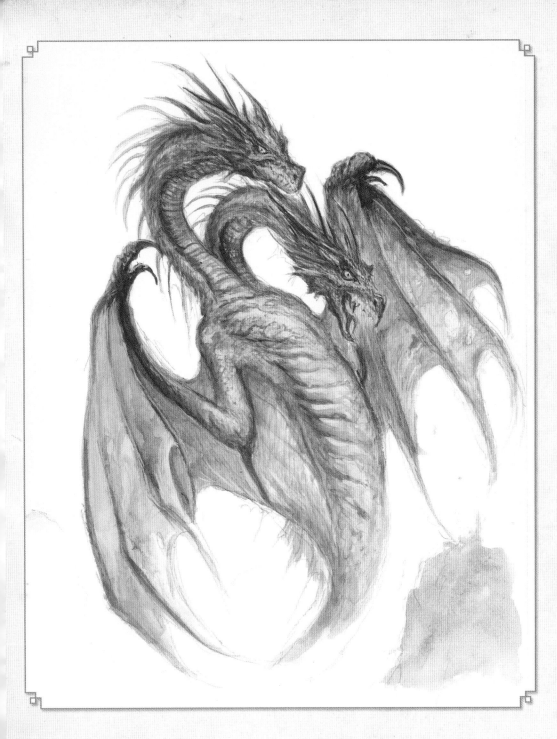

Step 14

With the dragon about done it's time to work in that background environment. This Orochi is flying over some exotic islands, high above the clouds. Add a very pale blue wash for the sky, and then start working those land forms in with gouache colours. Gouache is opaque and thus comes together rather quickly, so work confidently.

Start adding some texture to the sky, using really thinned colours – you don't want his body competing with the sky or bleeding into it. Finish adding in the islands beneath him.

Step 16

Paint in some tonal variations to the sky to give it some movement, which will then give the idea that the dragon is moving as well. Use your coloured pencils to finish up the rock forms, and add the last bits of detail to your Orochi's body. And here he is, your very own Eastern Dragon – I hope you can look after him for the next 800 years.

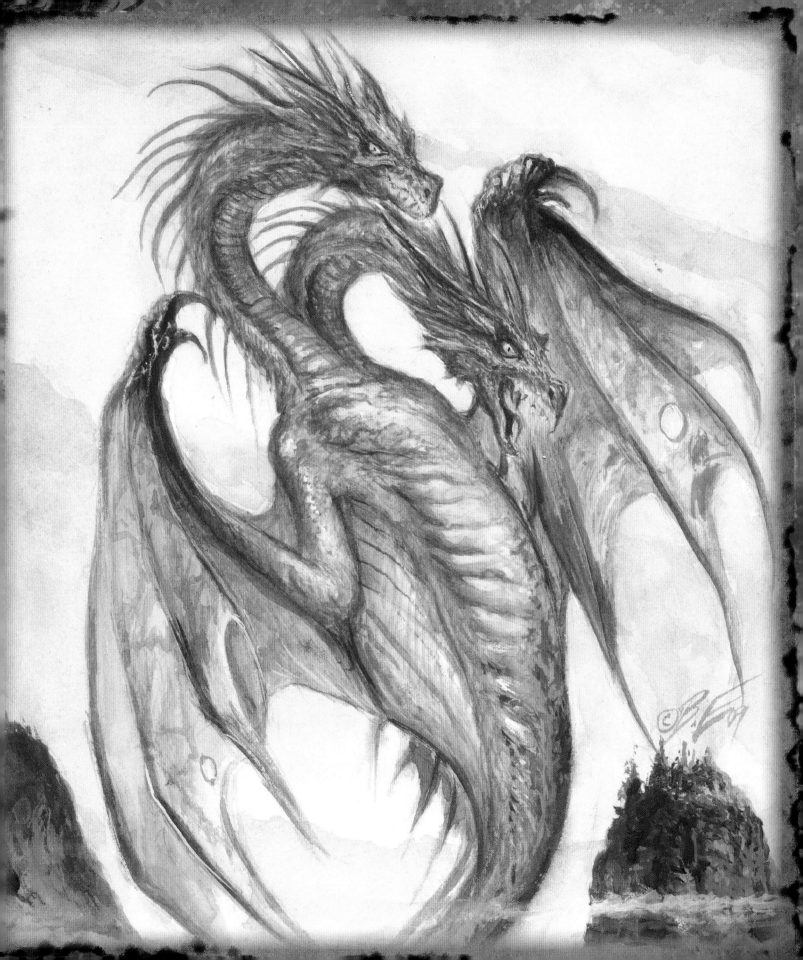

Volcanic Dragon

Volcanoes are amazing, and never more so than when in the midst of erupting. It's long been held that some Dragons live in volcanoes and under boiling magma from the earth's mantle. Some maintain that it takes this kind of heat to incubate the eggs of the dragon. What better setting than a raging hot volcano for this next dragon.

The Back Story

The Volcanic Dragon is that ultimate combination of flight and fire. Fearsome and brutal, it will stop at nothing to get what is wants, breathing fire onto anything in its path and leaving a wake of licking flames behind it. The Volcanic Dragon always uses its powers to create the utmost chaos and destruction, and will destroy any battlefield before the opposition even arrives. It swoops and dives, flying through the sky faster than the speed of light laying erupting volcanoes and lava flows to outwit its opponents who can only dodge the fiery obstacles. All hail this mighty dragon!

Materials

- HB-5B pencils
- Kneaded eraser
- Sketchbook
- Hot pressed watercolour paper, 2 ply
- Coloured pencils
- Sable watercolour brushes, Nos 4 and 6
- Watercolours (tubes or tray, your choice)
- Gouache(tubes) earth colours, magenta, blue

REFERENCES
Pictures of volcanoes erupting
Fire
Lizards and reptiles

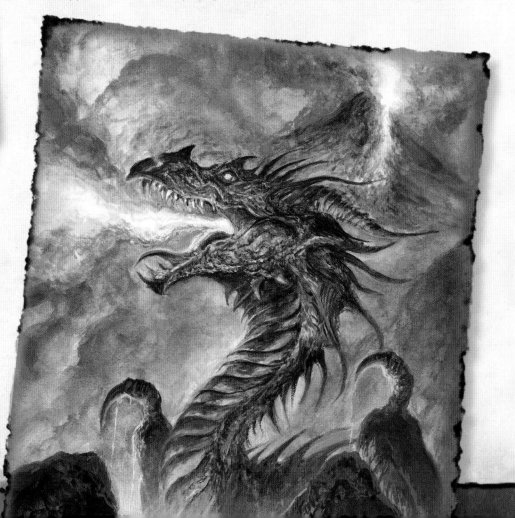

Step 1

Doodle and sketch your composition in your sketchbook until you're happy with how it's looking. The thrust and motion of this composition, combined with the setting makes it an irresistible and exciting piece to work on!

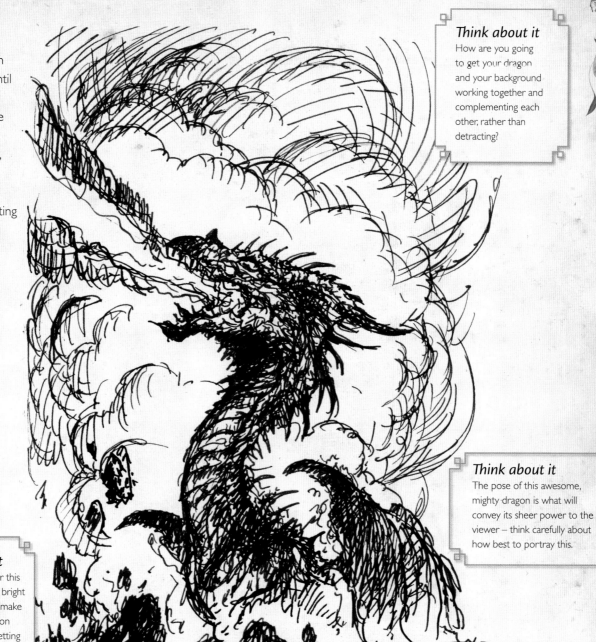

Think about it

How are you going to get your dragon and your background working together and complementing each other, rather than detracting?

Think about it

The pose of this awesome, mighty dragon is what will convey its sheer power to the viewer – think carefully about how best to portray this.

Think about it

The environment for this dragon needs to be bright and full of flame, so make sure your composition allows for a scene-setting background.

Step 2

Using an HB pencil, start working in your guidelines using quick and very light diagonal lines. You'll have to carefully erase them later, so be light. Work directly from your rough sketch to maintain the energy. With this workshop, draw directly onto the watercolour paper. You don't always have to create the roughs and then trace them onto your watercolour paper – if you're feeling good about a piece then work directly onto your finished paper (remembering to keep it light), as this will encourage your creativity and spontaneity.

tip

Check out the techniques of your favourite artists – J.M.W Turner, for example, used some interesting coloured pencil techniques that will work really well here.

Step 3

Further extend the lines and angles, paying attention back to your rough sketch. Give the head volume, and open the jaw to exhale fire.

Step 4

Keep working on your rough sketch, extending the lines you're happy with and using your eraser to remove the ones that you're not. Remember to keep it clean.

Step 5

It's really looking like a dragon now! When you think you've refined the dragon as far as possible, use your references to help you create the volcano in the background. A cone-shaped volcano brings interesting shapes to the image with our dragon sitting in a molten magma lake – pure heaven for a dragon!

Step 6

Keep refining your drawing, always keeping in mind that you will be applying transparent layers of watercolours, so the pencil lines have to be a concern. and must be kept light and few. There is nothing wrong with artwork that has pencil lines showing through here and there, but we definitely don't want them interfering with our inferno background!

Step 7

Release the fire! We're working with a very warm palette, so wash in Quinacridone Gold from its tube. Keep it very light, and use lots of water to thin out the colour and let it build up only in the shadow areas. Be careful to leave a white highlight in the middle of the flames coming out of his mouth, as this will look really good when he's finished.

Step 8

Start doing some detailing, all in the same colour. Begin building the fire from his mouth, always working from light to dark and allowing the colours to build up naturally in the shaded areas. Dab your brush onto the paper to create some interesting textures and variation in colours.

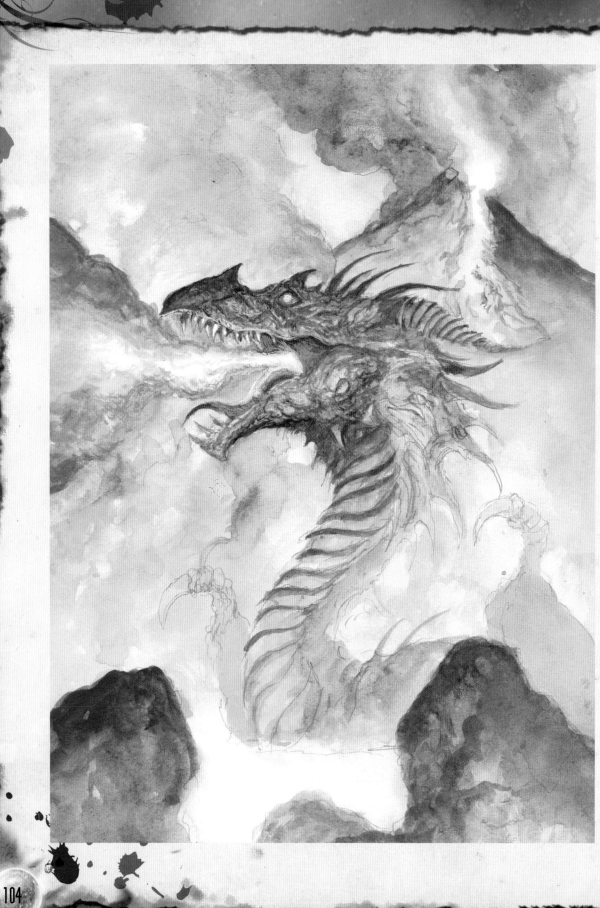

Step 9

Grab your gouache and use some blue in the fire and on the head. Using some darker Raw Umber, work this into the details and various cracks and crenellations. on your dragon. Remember that he lives in molten magma lakes, so will undoubtedly be rather burned in places.

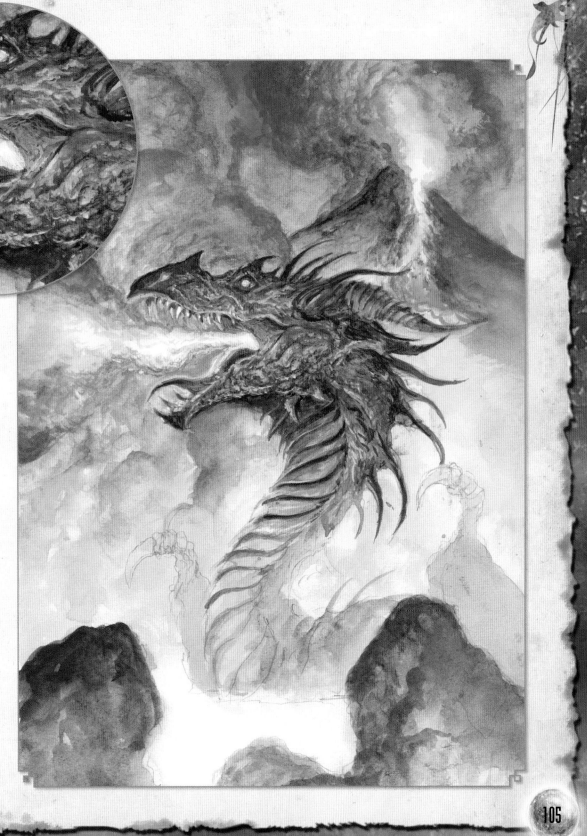

Step 10

Get into the mouth and work some magenta gouache, with a little Chinese White mixed in, to give the dragon some muscle to open his vast jaw. Work some blues and cooler colours into the background to push back some areas so that it's not all screaming hot colours. Make the eyes look as if they're glowing orbs – it's like the lava is coursing through his veins!

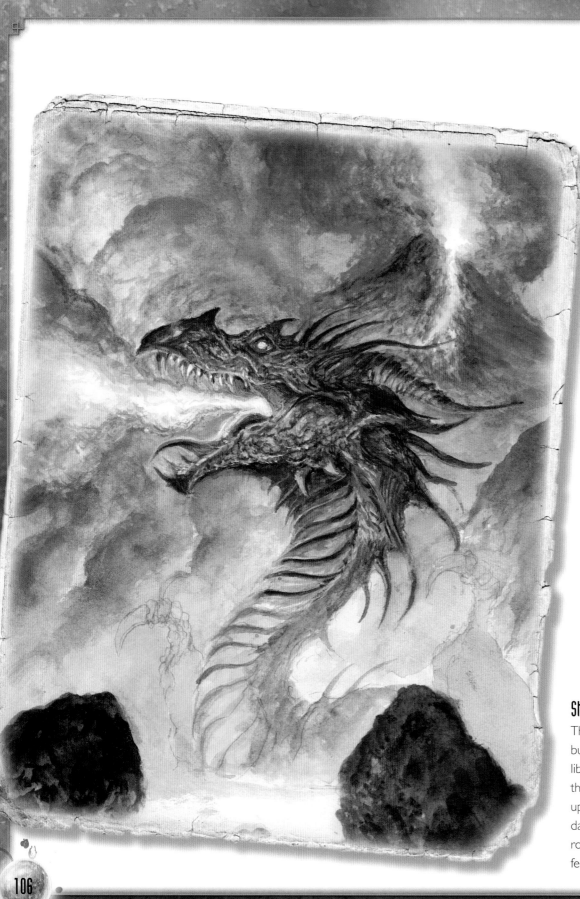

Step 11

The head is almost finished, but use your colour pencils liberally on the volcano and the cloud of smoke coming up in the background! Also darken those foreground rocks so that we have a feeling of depth.

Step 12

Time to turn your attention to his partly submerged wings and wing claws. Because the light is coming up from under him, this and the magma lake have been left until last. Use some darker umber colours to provide contrast and perspective.

Step 13

To pull out the rocks and make them look more three dimensional at the bottom, work in some Raw Sienna gouache over the darker watercolours. This also defines the rocks more so that they're a little more in focus than the wings, which are less detailed because they're in the middle ground and seen through a lot of heat rising up.

Step 14

Almost there! Using some purple and magenta gouache, start working back, in a contrasting way, into the darker areas of his body that face away from the light. This gives the shadows a rich look and creates a really nice colour contrast to the overall painting. Hope you like him!

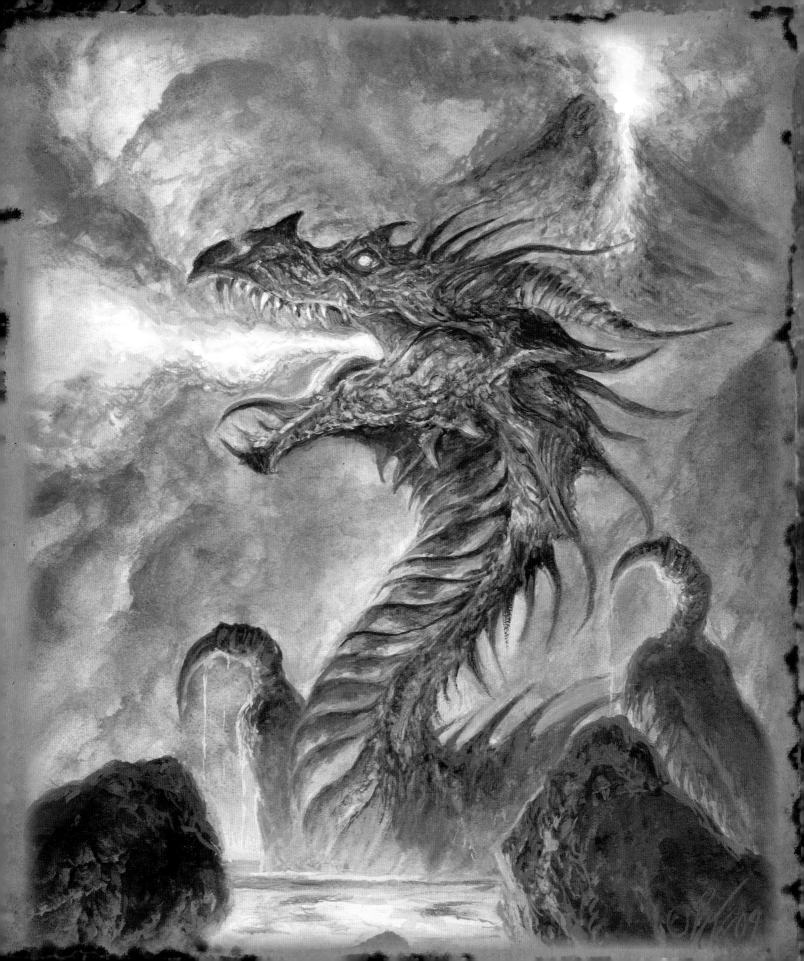

Elemental Dragon

The Elemental Dragon is a creature who lives for the wind under his wings. His wings are his most important feature, because they enable him to climb to great heights in the air and then to perch himself on mighty mountain cliffs, inaccessible to anyone but him.

The Back Story

Earth, fire, water and air. These are all the elements in the world, and each one is ruled by a dragon. Each dragon has a different personality, and possesses powers and forces that man can only ever dream of. Powerful and mysterious, these legendary creatures strike fear into the heart of everyone and everything.

Materials
- Charcoal pencil – soft
- HB-2B pencils
- Sketching paper or sketchbook
- Tracing paper
- Watercolours (tray or tubes)
- Goauche
- Watercolour sable brushes
- Coloured pencils (optional)
- Art tape, hardboard

REFERENCES
Photographs of different poses
Half-opened umbrella

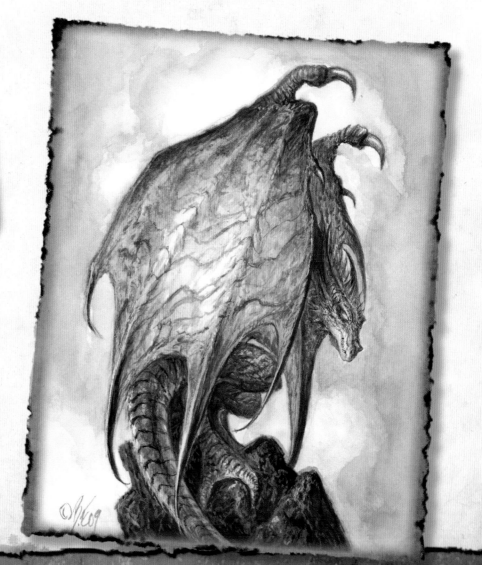

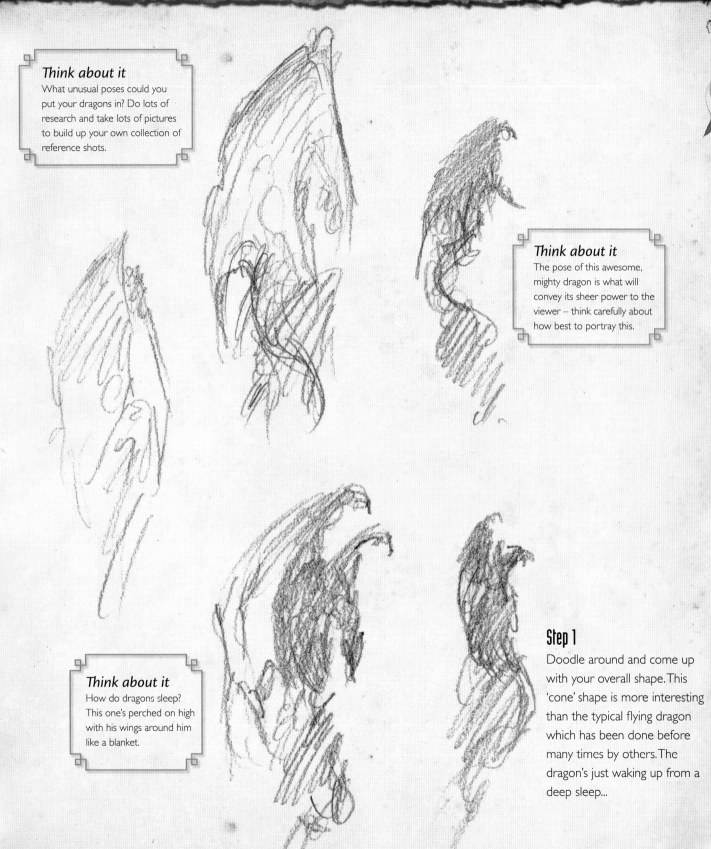

Think about it

What unusual poses could you put your dragons in? Do lots of research and take lots of pictures to build up your own collection of reference shots.

Think about it

The pose of this awesome, mighty dragon is what will convey its sheer power to the viewer – think carefully about how best to portray this.

Think about it

How do dragons sleep? This one's perched on high with his wings around him like a blanket.

Step 1

Doodle around and come up with your overall shape. This 'cone' shape is more interesting than the typical flying dragon which has been done before many times by others. The dragon's just waking up from a deep sleep...

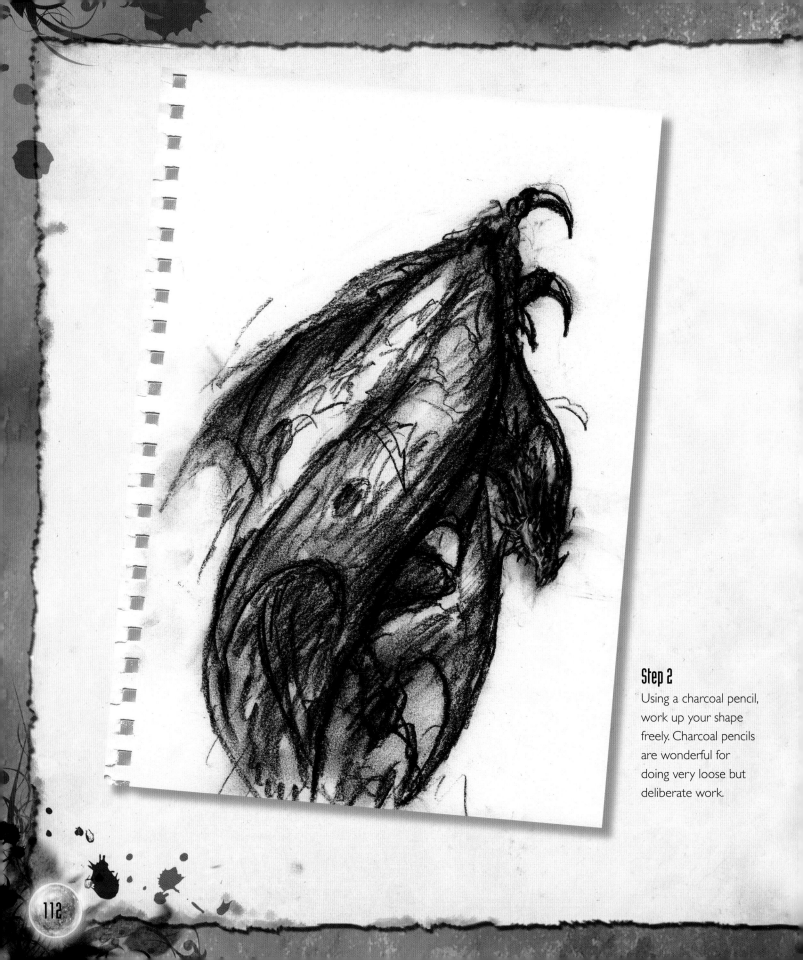

Step 2

Using a charcoal pencil, work up your shape freely. Charcoal pencils are wonderful for doing very loose but deliberate work.

Step 3

Time to take your initial lines onto the paper. As with the Volcanic Dragon, work straight onto watercolour paper using an HB pencil, and use this stage to really get your initial lines down.

tip

Whether you're drawing, painting or using pastels, always try to work from the whole arm, rather than just the wrist. You will get more fluidity in your movements and strokes.

Step 4

Work on the form and outline of the head until you're confident that, once you start working in colour, you can make it work just as you visualize it. Remember not to put too many lines on the paper, as they will need covering later on.

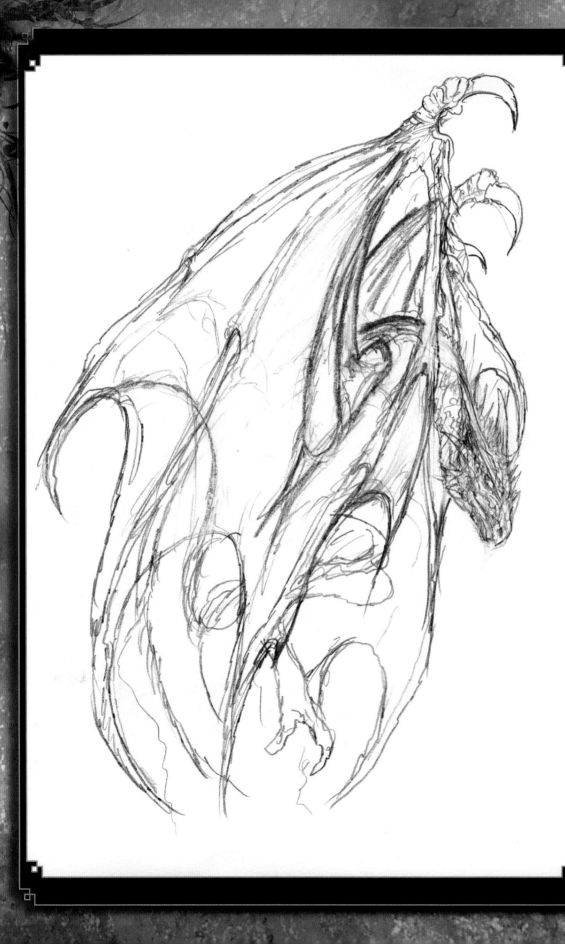

Step 5

Now's the time to work out the dynamics of the wings. It's important to make sure that they are working inside (where we can't see) as well as outside. Use a piece of tracing paper and lay it over your drawing. Onto that (not your final piece!), mark in the interior of the wings and how they connect to the body. This is a handy way of making sure that you know where you're going with the overall anatomy. It is marked in red here so that you can easily see what's been done, but you can do it in whatever colour you fancy.

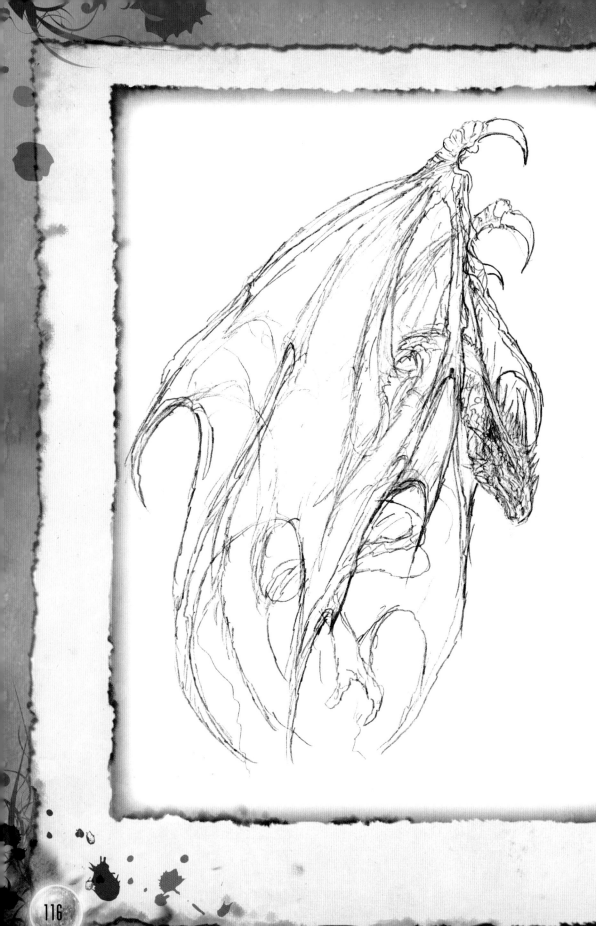

Step 6

This is more or less the finished drawing, ready for painting. Remove the tracing paper and check that you're happy with everything compositionally one last time. Tidy up any of the lines that you don't want using your eraser, so that the lines that are left on the page will remain in the final piece.

Step 7

Attach your paper to the
hardboard, taping on all sides.
Begin to liberally wash in some
greens and blues. Start working
on the colour details of his head.

Step 8

Looking good! Time to concentrate on his feet and legs. Make his legs solid and sturdy, and start working some nice patterns and highlights in on his wings, remembering your light source. After the colour has dried completely, use your kneaded eraser to remove any unwanted pencil lines and reduce the main lines to a less obvious level – don't remove them completely though, as you still have some work to do that you will need to see them for!

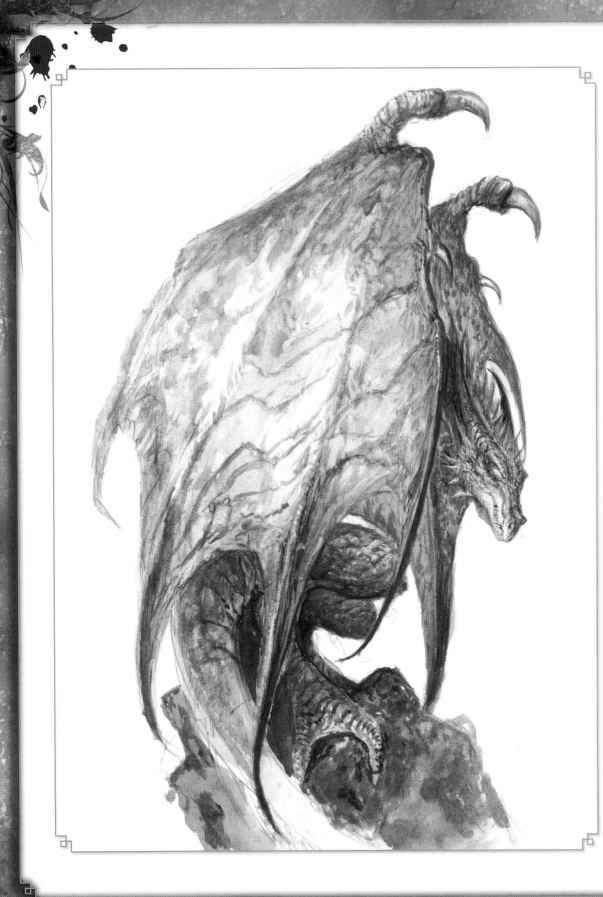

Step 9

His head is looking fairly finished now, so start working on the lower ends of his wingtips, darkening in the shadow under them and working more colour down the tail. Finish inside of his opposite wing with a decidedly pink/amber colour and interesting textures, suggesting something membranous. Finally, do some refining to the wing claws using a fine brush.

Step 10

Using a bit of Chinese White mixed with a little bit of gold green watercolour, get in with a fine brush and highlight points where the light hits the outer rib and membranes on the wings. Do the same on the ridges of his horns on his head.

Step 11

Nearly there! We just need some kind of sky around him – something vast and open to suggest he's about to take flight. Before you start that, work your way around the image with your kneaded eraser, zapping any unwanted guidelines that are still lingering.

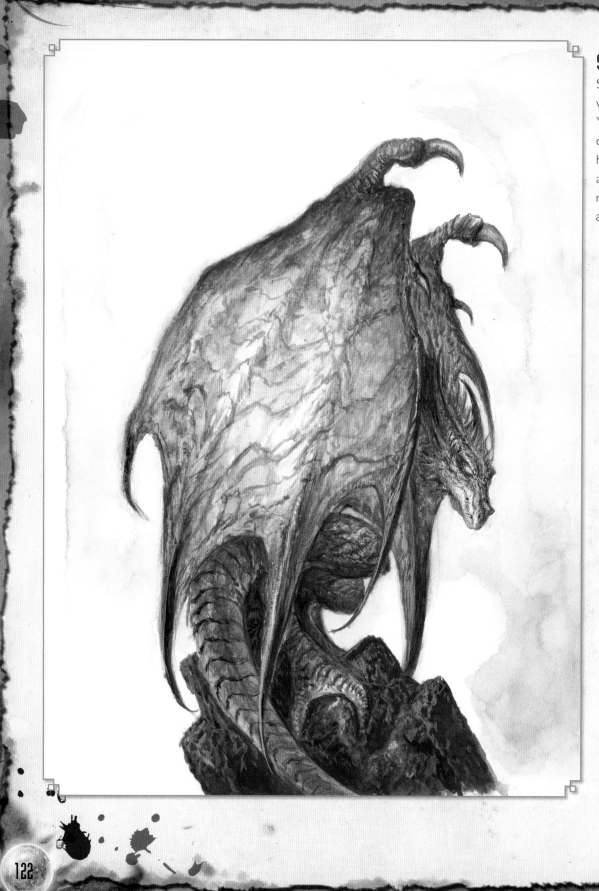

Step 12

Start washing in some light, very thinned Pthalho Blue. You're aiming for a feel of clouds and wind around him. Work some brown and black gouache into his rocky perch to give it weight and solidity.

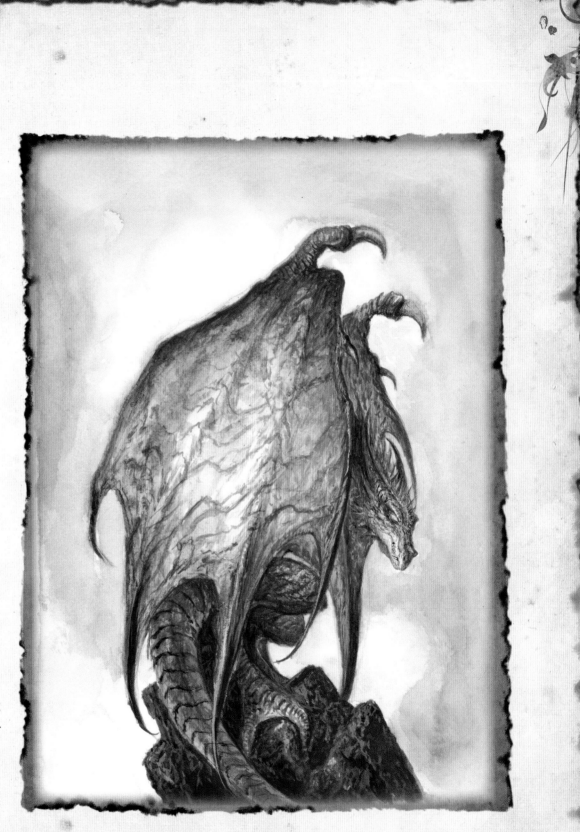

Step 13

Use some more blue to even the background out a bit. Start working in some light blue coloured pencil around his feet, head and tail, to suggest that the ambient sky light is reflecting on him.

Step 14

Time for one last trip around the wings. Use a variety of greens and blues to give that area near the head a little more visual weight.

Step 15

And here he is — all finished and looking rather nice! You can always come back to the piece at a later date to add some finishing touches or detail. Try to work on the image as a whole though, rather than just one area and don't over do it. The trick is knowing when to stop!

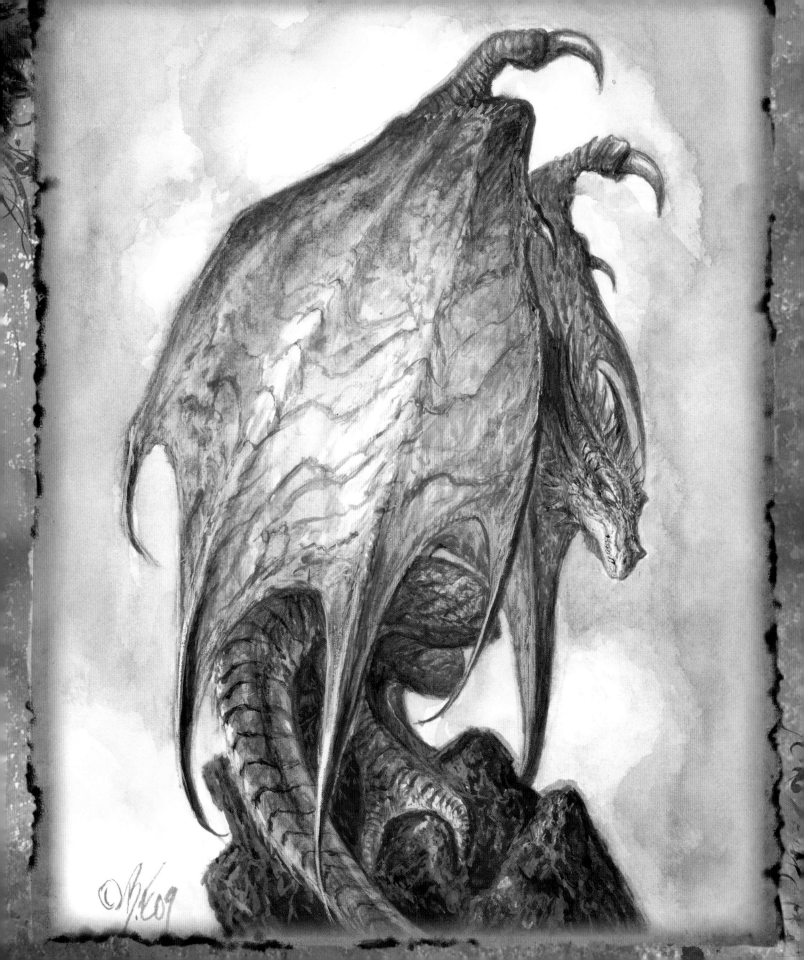

Acknowledgments

Thank you to Freya Dangerfield for keeping it all on track, Paul Barnett, Emily Pitcher for not only lighting the candle but putting it under the backside of yours truly to get him moving, Mia Farrant for her wonderful design work, Steve Hart, Jonathan Grimes, Erin Blackman, Fran Paliotta, John A. Davis, all my friends, all the fans, and my wife Marianne Plumridge for putting up with me while I went through the tunnel seeking the light at the end.

About the author

Bob Eggleton is a legend in the field of Sci Fi and Fantasy Art, having won a total of nine Hugo Awards, two Locus Awards, The Skylark Award and 12 Chesley Awards for his work and contributions to the genre. He was a conceptual artist on the films *Jimmy Neutron Boy Genius* (2001), *The Ant Bully* (2006) and contributed special effects designs to *StarTrek* and the film *Sphere* (1997) and the short Independent film *The Idol* (2007). He has illustrated bookjackets to authors such as Robert A. Heinlein, Arthur C.Clarke, Buzz Aldrin and William Shatner.

Picture Credits

Studio photography pages12–15 Fran Paliotta

Colour step by step photography of The Quintessential Dragon 46–53, Fran Paliotta

Additional Photography/pages 32, 34–37 Marianne Plumridge

Artwork Page 33 by Gustave Dore, courtesy of Dover Books

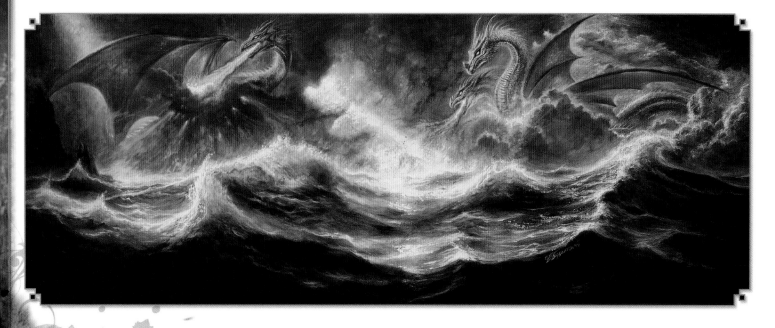

Index

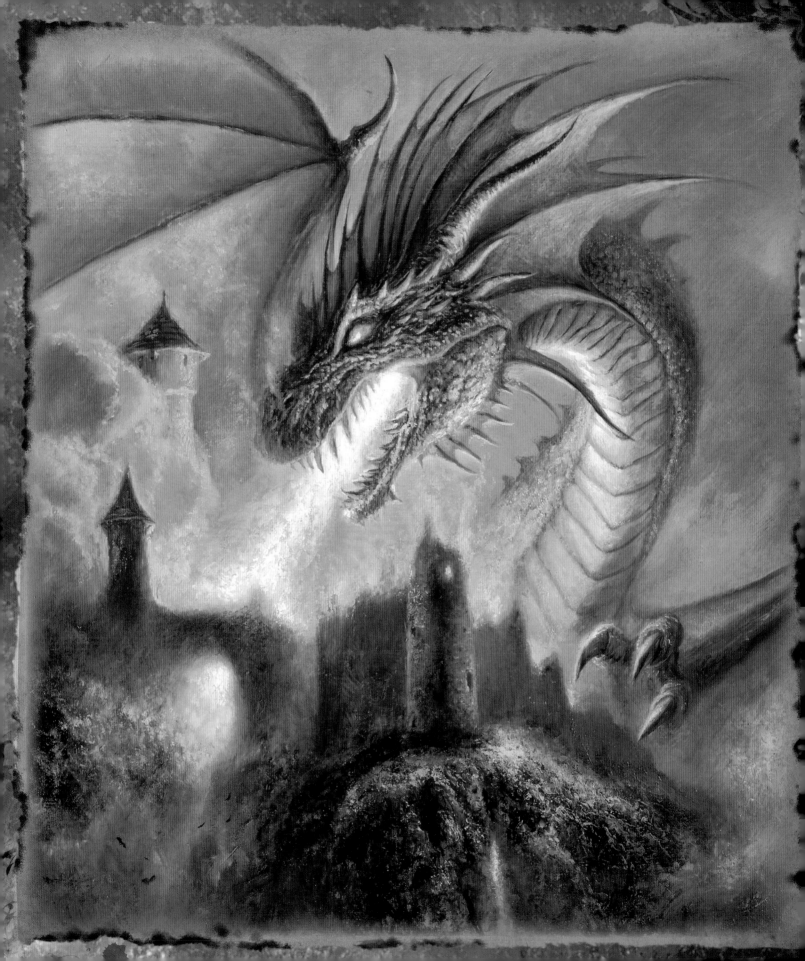